4—

Meiji Western Painting

EDITORIAL SUPERVISION
FOR THE SERIES

Tokyo National Museum
Kyoto National Museum
Nara National Museum

with the cooperation of the

Agency for Cultural Affairs
of the Japanese Government

FOR THE ENGLISH VERSIONS

Supervising Editor
John M. Rosenfield
Department of Fine Arts, Harvard University

General Editor
Louise Allison Cort
Fogg Art Museum, Harvard University

MEIJI WESTERN PAINTING

by Minoru Harada

translated by Akiko Murakata

adapted with an introduction by Bonnie F. Abiko

New York · WEATHERHILL/SHIBUNDO · *Tokyo*

This book appeared originally in Japanese under the title Meiji no Yōga *(Meiji Western Painting), as Volume 30 in the series* Nihon no Bijutsu *(Arts of Japan), published by Shibundō, Tokyo, 1968.*

The English text is based directly on the Japanese original, though some small adaptations have been made in the interest of greater clarity for the Western reader. All Japanese names are given in the Japanese style (surname first).

For a list of the volumes in the series, see the end of the book.

First edition, 1974

Published jointly by John Weatherhill, Inc., 149 Madison Avenue, New York, N.Y. 10016, with editorial offices at 7-6-13 Roppongi, Minato-ku, Tokyo; and Shibundō, 27 Haraikata-machi, Shinjuku-ku, Tokyo. Copyright © 1968, 1974 by Shibundō; all rights reserved. Printed in Japan.

ISBN 0-8348-2708-5 (hard) 0-8348-2709-3 (soft) LCC 73-88475

Contents

Adapter's Preface

THIS BOOK is an adaptation of the original work in Japanese by Minoru Harada and is largely based on the translation completed by Akiko Murakata. Parts of the book have been expanded in order to place it in its art historical context, which may be unfamiliar to the Western audience; the original ideas put forth by Mr. Harada have, however, been retained.

In traditional painting, the Japanese artist interpreted nature through his mind's eye and the rapid flow of his brush. Western-style painting introduced an entirely different approach: the artist was to reproduce natural forms as they appeared before his eyes, to exchange his inner vision for an outer one. While the Japanese artist was faced with this challenge, his Western counterpart was beginning to replace an objective orientation toward nature with a more subjective one. Each Japanese painter was therefore required to undergo a complete reorientation of aesthetic values, and it is this wrenchingly difficult process that emerges as the theme of Mr. Harada's text. This change of view and absorption of new techniques were being pursued in the search for a new Japanese style of art, a search that has continued even to the present.

I would like to express my gratitude for the many hours of discussion with Japanese friends who were willing to help deepen my understanding of aspects of Japanese aesthetic thought and of this transitional period in Japanese history, while reserving to myself and Ms. Murakata the responsibility for any errors of translation or interpretation.

B. F. A.

Introduction

"THE MASTERS ARE IMMORTAL, for their loves and fears live in us over and over again. It is rather the soul than the hand, the man than the technique, which appeals to us—the more human the call, the deeper is our response." Okakura Tenshin wrote these words in his *Book of Tea* about paintings related to the aesthetics of tea at a time when he had been for many years deeply involved in the cataclysmic changes altering the forms of traditional painting styles of the East. He was among those in the intellectual circles of Meiji Japan (1868–1912) who tenaciously defended traditional Eastern art and philosophy while also recognizing that the times required a deeper understanding of Western art. It was his hope that the essentials of Western art expression and traditional Japanese ideals could be fused into a style representing the best of both cultures.

In contrast to Okakura's ideal, the Japanese painters of Western-style painting discussed by Mr. Harada in this book were seeking to cast off tradition and absorb European forms. They were abandoning silks and papers for linen canvas; handscrolls and screens for framed pictures; soft, pliable animal-hair brushes for stiff European-made brushes; and stone-rubbed inks for thick oil pigments. As an art form transplanted from the West, oil painting came to be called *yōga*, Western-style painting, to differentiate it from *nihonga*, Japanese-style painting. In the latter, the traditional medium of water-soluble pigments on silk or paper continued to be used. *Yōga* and *nihonga* have been produced side by side ever since, their styles often intermingling and at times becoming indistinguishable. The basic distinction in both material and method, however, has continued until the present time.

In looking back over the work of the *yōga* painters a century ago, we are often more aware of the painful efforts of the artist searching and experimenting with Western techniques than of the drama within the man, and it is possible that the same artist, in a period less rocked by cultural change, would have been an undisputed master of a more familiar style. Many *yōga* artists in the early Meiji years began their training in *nihonga* before learning the disciplines of oil painting, and all were talented men.

The times that could accommodate the opposing view of artists pioneering in Western painting techniques as readily as the aesthetic ideal of the East held by Okakura Tenshin was the short half-century during which Japan put forth immeasurable energy to achieve a level of modernization equal to that of the West. As Japan emerged from two hundred and fifty years of enforced isolation from the rest of the world, it was imperative that she reorganize in response to the challenge of the Western powers and the opening of Japanese society to foreign influence. Once this process of modernization was under way, there was no stopping it; by the turn of the century, Japan was technologically able to wage a successful war against Russia, politically able to govern through a cabinet and parliamentary system, and economically able to maintain a vital heavy industry and commerce. To arrive at this remarkable level of development, the Meiji government sent numbers of Japanese with specialized interests to Europe to study government, medicine, law, and education for the purpose of adapting Western ideas into the new structure. This total change was no less felt in the arts, and especially in painting, where a thousand years of tradition had molded a refined sense of beauty, a wide range of artistic disciplines, and official styles supported by a strong and wealthy patronage.

By the middle of the nineteenth century, the traditional art forms were as unsuited to meet the new challenge of the West as were political and social institutions. The official Kanō and Tosa schools supported during the Edo period (1603–1868) by the military government and the imperial family, respectively, were repeating themes and motifs rooted in medieval Japanese culture, and though the skill displayed in the paintings was of the highest quality, originality and inspiration were obviously lacking. Other schools had appeared along with the official ones to fill the constant demand for art, a few of which had even absorbed certain principles of Western art. But a full exploration of Western-style art was not possible until society at large was ready for total commitment to modernization. Once this commitment was made, the momentum in aesthetic change was as breathtaking in the arts as it was in the social and political realms.

The timing of this profound encounter in the 1870s and 1880s between young Japanese artists willing to cast off their traditions and the art of Europe coincided with the revolution taking place in French art circles, where painters were disputing the academic style established by the masters of the Renaissance, which had remained relatively unchanged until the ferment of the nineteenth century. Fritz Novotny in *Painting and Sculpture in Europe, 1780 to 1880* wrote: "The causes of this change which lay outside art itself have been often and amply explained: the radical changes in the structure of society —the disturbance of secular and ecclesiastical power on the Continent as a result of the French Revolution . . . the subsequent beginnings of a democratic society and a new form of individualism: the consequent fundamental change in the relationship of the artist to society, both as his patron and his milieu. The significance of this new situation involving the destruction of all links with the past and the emergence of a new freedom for art and the individual artist, is in part obvious: it opened the way for a new view of the world." These changes affecting Europe and its art could be equally well applied to the changes altering Japan and her art. However, young Japanese painters, in the West for the first time, were not supported by a background in Western art history to guide them through the maze of new art theories. The European artists of the nineteenth century were consciously casting off the scientific views that underlay much of the Renaissance imagery and style, while the Japanese painters were approaching this same style with no scientific theories to refute, with a totally fresh view of the nineteenth-century movements, but with a feeling of dislocation from their own tradition. Their

effort in Europe was further complicated by their having to cope with the constantly modified theories of light and color and with the increasing expressiveness on the part of the artist. Entering midstream into the movements of the nineteenth century, these Japanese painters did not have in their own past the centuries of familiarity with Raphael, da Vinci, Dürer, and Rembrandt, and were plunged unaided into the whirlpool of European taste.

This background may explain to some degree the initial disquiet usually felt by Westerners today when faced with the work of these *yōga* painters: As works of art, the paintings exhibit remarkable skill in the use of the oil medium, but they are often unconvincing because they are not truly Western in feeling nor thoroughly resolved as a Japanese art form. If the mid-nineteenth century in Europe was in fact an era of tumultuous experimentation, it is not surprising to find the Japanese *yōga* painters also exploring new ideas and styles, and moving back and forth between Western and Japanese motifs. Within a brief span of three years, for example, Harada Naojirō produced the *Shoemaker* (Plate 16), which evokes psychological depth through the austere background color and the intense shading of the face, and the *Kannon Riding on a Dragon* (Plate 15), which is a total reversal in subject matter in the flattened surface texture, and in the cool remoteness that exists between the artist and his subject. In another example, Fujishima Takeji's range of style and theme seems curious indeed: it moves rapidly from his austere maiden (Plate 87) in 1902, to the ethereal quality of *Butterflies* (Plate 90) in 1904, to the rich, painterly texture of *Yacht* (Plate 95) in 1908 and the freely styled portrait *Black Fan* (Plate 91) in 1909. Fujishima's flexibility also illustrates a major flaw of the work of this era and that of the Taishō era (1912–26) as well: These were brief periods of experimentation in many styles without an attempt to digest any one before moving on to the next. In addition, time has not been kind to many of the early Meiji paintings, which were rendered with inferior oils and improvised brushes and canvases. Without adequate undercoating and preparation of the canvas to prevent the darkening of pigments, many of these early paintings have faded and changed beyond recognition.

Mr. Harada in this book is deeply concerned with the dilemma of split identity that was forced upon Japan at this time—the dual problem of guarding tradition while modernizing along Western lines. His approach to this survey of Meiji Western-style art is therefore based on two questions: How did oil painting as a Western art form with no tradition in Japan change once transplanted into an entirely alien culture, and what effect did this new art style have on the ideas and attitudes of Japanese painters? Although there are no direct and conclusive answers to these questions, they form the underlying theme of this study of the development of Japanese Western-style painting from its beginnings as a utilitarian skill used in conjunction with cartography and other engineering sciences into an acceptable form of artistic expression. Looking back over this half century of modern *yōga,* we can bring four distinct periods into focus. The first, which includes the last years of the Edo period and the first years of the Meiji era (the 1860s to the 1870s), is the time when pioneer efforts were made to acquire the techniques of Western painting. In the next two decades Western-style painting in Japan attained a measure of stability, having survived the pressure of a domestic ultranationalist movement. The early twentieth century was marked by the emergence of the Impressionist *plein-air* movement led by Kuroda Seiki, often considered the founder of modern Western-style painting in Japan. The fourth period, the five years from 1907 to 1912, spans the time of the annual exhibitions sponsored by the Ministry of Education and climaxes a half-century filled with contradictions between traditional forms of expression and the newly absorbed artistic techniques and outlook. It is perhaps fair to say that the work of the genera-

tion before World War II was essential in preparing Japan for the major role she would play in the so-called international style of the postwar period, in which modern art in Japan could be considered a totally creative and original expression.

There is a problem of judgment set before the reader as well as before the art historian in dealing with Meiji-era art. As an art form transplanted into a culture already rich in its own aesthetic tradition, should Meiji art be judged from the standpoint of Western nineteenth-century art, or should it be judged by Japanese aesthetic standards? If we use the first criterion, the paintings of the best Meiji artists, though inferior to those of the best of the French painters, rank closely in skill and chromatic harmony with other works produced in Europe, and are on a par with much American painting of the same time. And for the Japanese pioneering in Western art principles, there were insufficient first-rate examples of original Western art to learn from or to use to develop valid criteria for judging the quality of *yōga* painting. From the standpoint of Japanese aesthetics, Western imagery was totally removed from the traditional concept of artistic quality, which stressed such mystical principles as "life force" or "spirit movement." In traditional Eastern painting, any attempt to reproduce an object in its lifelike reality was left to the skills of the artisan or craftsman and considered unworthy of the gifts of a true artist.

E. H. Gombrich, in his *Meditations on a Hobby Horse,* was reflecting on the mighty role of tradition in creating and perpetuating forms of art; in his view, the invaluable role of tradition was especially visible when "one artist [can] learn from another and can add to his achievements and discoveries." With no such background or opportunity, the early *yōga* painters' grasp of a completely foreign expression is truly remarkable.

One further point that should be noted here is the approach taken by the author in writing about a Western art form, for Mr. Harada's basis for evaluation is often different from that found in Western criticism. If it is the life and spirit of the brush and the subtle variations of line and texture that evoke images in Eastern art, it is often by the subtleties of mood, color, and life of the brush by which the quality of a painting is evaluated here; the Western reader himself must provide the more purely formalistic analysis native to his way of seeing and judging a work of art. If, as Okakura wrote, "the more human the call, the deeper is our response," then the author has opened to us through his book a human dimension in Meiji art history in addition to a critical evaluation.

Meiji Western Painting

1

Pioneer Artists

The introduction of Western painting to Japan can be traced back to the sixteenth century, when religious paintings accompanied the earliest Christian missionaries to Japan and Japanese converts to the faith began producing their own works in native seminaries. This activity was suddenly curtailed a century later by the suppression of Christianity in Japan and the policy of isolation adopted by a military government (known as the shogunate) intent on maintaining its own position in the face of Western colonization in East Asia. By the eighteenth century, limited contact with European culture through the Dutch merchants isolated at Nagasaki had begun to stimulate a new interest in "Dutch" studies within a select group of intellectuals interested mainly in Western scientific methods. Among these men were artists fascinated with European portraits and landscapes rendered in uncanny, lifelike reality by techniques of perspective and shading totally foreign to Japanese art traditions.

Among the most influential artists in the early exploration of Western styles were two men who were not themselves professional painters: Hiraga Gennai (1727–79) and Shiba Kōkan (1747–1818). Gennai was a botanist and amateur painter who was interested particularly in Western scientific illustrations and in the laws of perspective. Kōkan was moved to investigate areas of Western knowledge in depth because of his own discontent with Japanese culture, which he felt was backward. His early training in art prepared him for his pursuit of Western art principles, which he found useful because they "portrayed light and shade, the shapes of solids and their perspective"

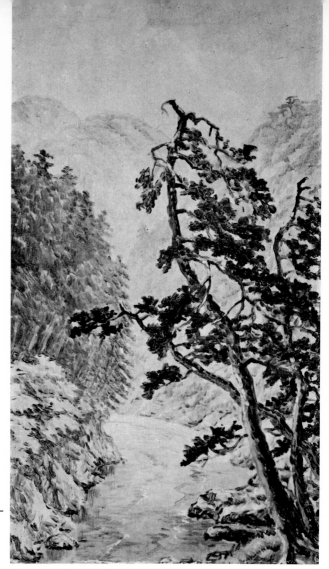

1. Kawakami Tōgai: Landscape. Oil. Early Meiji era. To-kyo National Museum.

and were convenient for depicting things difficult to explain in words. With unflagging curiosity, such men studied Western landscapes and portraits, usually through the medium of engravings and illustrated books. The uniquely primitive versions of Western-style art these early artists produced have fortunately survived the intervening years in fair quantity, and are valuable resources for the study of how Western art developed in Japan.

Two other artists, pioneers in the effort to assimilate a sense of Western art, were Maruyama Okyo (1735–95) and Watanabe Kazan (1793–1841), who were themselves professional artists. Okyo began his career as an apprentice in the Kanō school, officially patron-

ized by the government, which specialized in Chinese-style ink painting and in the bold, colorful imagery of *yamato-e,* the traditional Japanese style. Rebelling against the formalism and rigidity of the academic Kanō school, he struck out on his own. The school he established was patronized largely by wealthy Kyoto families, and the principles on which it was run incorporated elements derived from those of Western art. Watanabe Kazan, one of the most distinctive painters of the late Edo period, was a samurai artist of the Nanga school, a group of amateurs and scholar-artists who painted in a purely personal style in monochrome ink. Among Kazan's innovations were efforts to penetrate the flat plane of traditional painting with

2. *Kawakami Tōgai:* Kayabe, Hokkaidō. *Oil. c. 1877.*

elements of shading and depth perspective borrowed from the West. Portraiture in particular gained a freshness from his adept combination of line drawing and limited use of shading to model his forms.

The Bansho Shirabesho

These preliminary explorations were, however, almost extinguished in the social disruption that marked the early and middle decades of the nineteenth century. Commodore Perry's visit to Uraga and the Russian mission to Nagasaki in 1853–54 created diplomatic and domestic crises for Japan, and to provide itself with information about the threatening lands of the West, the shogunate established the Institute for Western Studies, or Yōgakusho, in 1855. Within a year, it was renamed the Bansho Shirabesho, or Institute for the Study of Western Documents. The only similar government institution before this had been the Astronomical Observatory, where a world atlas had been translated and compiled, and a translation of Chomel's *Encyclopedia,* originally *Huishoudelijk Woordenboek,* a Dutch publication of seventy volumes, was produced in 1837. The Chomel work was not an encyclopedia of knowledge, but contained useful information on the practical aspects of Western life.

Studies in Western-style painting were begun anew at the Bansho Shirabesho, but only as a means to

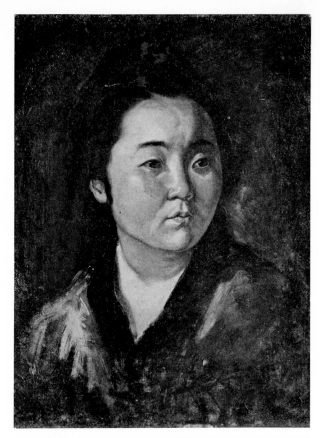

3. *Charles Wirgman:* Portrait of Kaneko. *Oil. Early Meiji era. Tokyo National Museum.*

promote industrial development and military skills through map-making and descriptive drawing. Oil painting was accepted as a utilitarian discipline along with agriculture, metallurgy, and mathematics, to be quickly mastered in the race to catch up with the West; but it was not studied as a form of aesthetic expression possessing its own intrinsic value.

In the 1860s, the Bansho Shirabesho, now renamed the Kaisei Gakkō, began to instruct the sons of samurai in Western scholarship, to conduct research on a broad range of Western documents, and to train experts in Western disciplines. Following a series of reorganizations during the turbulent years of the Meiji Restoration, the Kaisei Gakkō formed the nucleus of what was to become Tokyo University in 1877. Although the work of the Bansho Shirabesho was undoubtedly a valuable first step toward systematic official study of

Western-style painting, the artistic, experimental approach of a Gennai or Kōkan was lacking, and the utilitarian view of Western-style painting tended to stifle any immediate possibility of its becoming an independent art style.

Kawakami Tōgai

Tōgai (1827–81) was born a farmer's son in Matsushiro, Shinano Province (modern Nagano), in the mountains of central Japan, and at the age of eighteen left home for Edo to pursue Western studies. He then became the adopted son of a samurai by the name of Kawakami, and it was through this connection that he was accepted into the Bansho Shirabesho in 1856.

He had shown a distinct inclination for painting

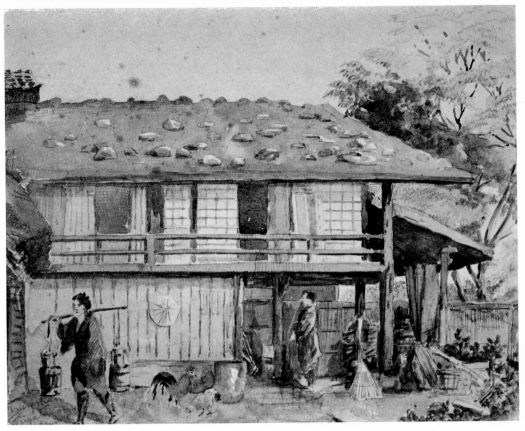

4. Charles Wirgman: House in Niigata. *Watercolor. Early Meiji era. Tokyo National Museum.*

since childhood, and in Edo became the student of Onishi Chinnen (1792–1851), an exponent of the realistic Shijō school, who bestowed on him the artistic name Tainen. When the Painting Division was established at the Bansho Shirabesho in 1861, Tōgai was placed in charge, giving him a position in which he could devote himself to learning the techniques of Western-style painting.

His research in the Painting Division was earnest and painstaking, but he was forced to work under crucial limitations. For one thing, there being no genuine examples of oil paintings available to him, he was confined to a small number of Dutch books. Lacking conventional oil pigments or canvases, he devised a mixture of silver monoxide dissolved in perilla oil; at other times he used lacquer and traditional Japanese materials as substitutes. In place of canvas, he improvised with glazed Mino paper, a thick, tough handmade paper, sometimes cloth-backed. His brushes were either his own creation or custom-made to his specifications by Japanese brushmakers. Although this dearth of proper materials was somewhat eased by a supply brought back by a government mission returning from Europe in 1862, these early efforts were made under the most adverse conditions.

Tōgai also assumed responsibility for the younger men in the Painting Division, and among those who received his tutelage was Takahashi Yuichi, a major figure in the first generation of *yōga* painters. Besides his post at the Bansho Shirabesho, Tōgai was affiliated with various institutions throughout his career, including the Numazu Military School, the Daigaku Nankō (successor to the Bansho Shirabesho), the Military Academy, and the Ministry of War. In 1869 Tō-

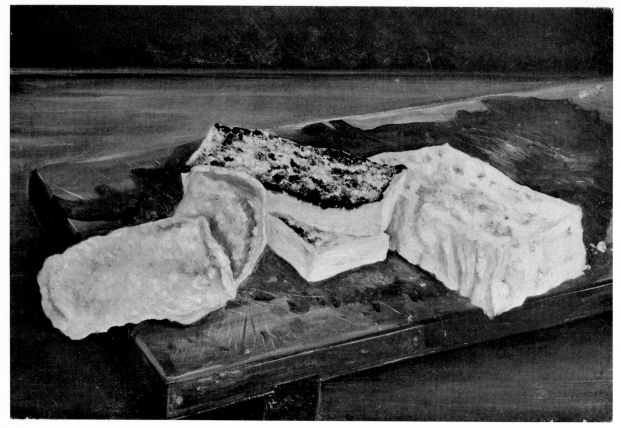

5. *Takahashi Yuichi: Bean Curds. Oil. c. 1877. Kotohira Shrine, Kagawa Prefecture.*

gai opened a private studio, the Chōkō Dokuga-kan, in Shitaya in east Tokyo, to train his young students. The group of painters usually connected with this atelier are Koyama Shōtarō, Nakamaru Seijūrō, Kawamura Kiyo-o, and Matsuoka Hisashi, who worked together to popularize Western-style painting in early Meiji Japan.

Only a few of Tōgai's works remain, and his completed oil paintings are particularly rare. *Landscape* (Plate 1) painted in 1870, is a valuable example of the experimental nature of his work. The valley and stream are skillfully enough organized according to the laws of Western perspective, yet the shape of the traditional hanging scroll automatically conveys an impression of nature conceived from imagination rather than sketched from direct observation. Al-

though the use of oil definitely places this work in the category of Western-style painting, Tōgai's style clearly reveals his early training in the Nanga school. By contrast with the vertical *Landscape,* Tōgai also painted a study of a forest in Hokkaidō during an expedition to the northern island in preparation for a government program to develop the territory. The painting (Plate 2) illustrates the high level of skill he had achieved in the use of Western painting techniques. This eclecticism is often said to be symptomatic of his immaturity as a Western-style painter, though a deeper understanding of Tōgai and his art is needed for an adequate explanation of his stylistic idiosyncrasies.

Tōgai's overriding utilitarian view of Western art unfortunately veered little from the established policy

6. *Takahashi Yuichi:* Oiran. *Oil. c. 1877. Tokyo University of Arts.*

7. *Takahashi Yuichi:* Portrait of Shiba Kōkan. *Oil. c. 1875. Tokyo University of Arts.*

of the government. Apart from his public duties and his title, which linked him professionally with the study of Western art principles, his reputation was solidly established as an artist of the Nanga school. Furthermore, *nanga* was more natural for him as an aesthetic expression, though he practiced it only privately. The fact that he always consciously maintained a distinction between the two styles may explain to some extent why his Western-style painting never evolved into a mature artistic expression and, further, why the mood of *Landscape* is so heavily weighted on the side of the *nanga* tradition.

Such a tightly held, pragmatic view of Western-style painting was not limited to Tōgai alone; the obvious lack of freedom in early *yōga* may well be attributed to the narrow frame of reference within which the painters worked. Among Tōgai's many students, only in the case of Takahashi Yuichi is there a striking divergence and a serious attempt to achieve an emotionally expressive art form.

Takahashi Yuichi

Without question, Takahashi's best-known painting is *Salmon* (Plate 12), painted around 1877. This oblong work, which depicts the body of a partly cut salted salmon hanging by a straw rope, is a powerfully evocative image, one of the most memorable products of Meiji realism. The gaping area of flesh and bone and the dim, silvery gleam of the scales seem as tangible as if within a hand's reach. The painting, however, is much more than a simple reproduction of the external

8. *Takahashi Yuichi:* Miyagi Prefectural Hall. *Oil. 1891. Miyagi Prefectural Library.*

form of the object. What attracts and then holds the viewer's interest is Takahashi's attempt to express his interpretation of the physical object. This infusion of the artist's own view and sensitivity gives *Salmon* a revolutionary character far removed from the Bansho Shirabesho's pragmatic attitude toward Western-style painting, and marks it as the first *yōga* painting conceived purely as a work of art.

Takahashi (1828–94) was born in Edo (present-day Tokyo) to a family of hereditary archery and fencing teachers for the Hotta family, lords of Sano in the province of Shimotsuke (modern Tochigi) in the north. At nine, he was made attendant to the lord, and about that same time began studying art under the direction of a painter of the Kanō school. His commitment gradually shifted until finally he resolved to become a professional painter. What ultimately attracted him to *yōga* was the realistic imagery he observed in the several Western lithographs he happened across. The *Takahashi Yuichi Rireki* (The Career of Takahashi Yuichi), edited by his son Genkichi, quotes the artist as saying: "It was during the Kaei era [1848–54] that I borrowed a collection of Western lithographs from a friend, and discovering how very realistic they were, with their own life and character, decided to study the art."

These early Western-style painters were all motivated largely by the curiosity and admiration they felt toward the realism of Western art. Takahashi was no exception, but the fact that he was able to perceive a "life and character" in the lithographs he saw put him a step ahead of the current trend of thought. His

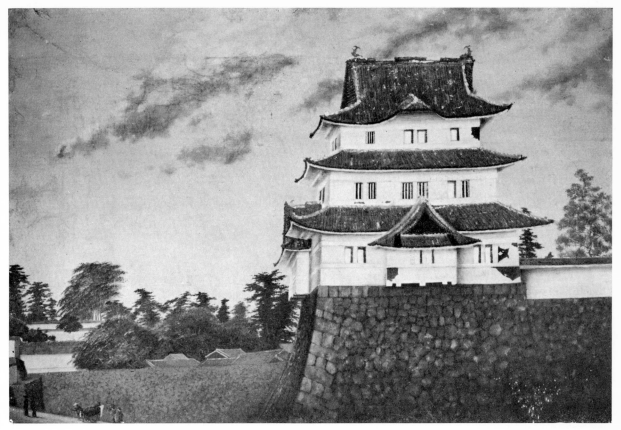

9. *Yokoyama Matsusaburō: Old Edo Castle. Oil. Early Meiji era. Tokyo National Museum.*

contemporaries found in Western art the principles that would enable them to reproduce the appearance of physical forms with photographic realism, but they did not consider these techniques a viable form of artistic expression. On this point, Takahashi differed from Tōgai, for example. Takahashi proceeded to seek an understanding of Western art from direct experience, and it was with this goal in mind that he embarked on a career as a *yōga* artist.

He joined the Bansho Shirabesho in 1862, and began to work with intense concentration and energy. Soon dissatisfied and constrained by the conservatism of the institute, he set out to learn painting techniques directly from a Westerner. After making inquiries, he sought out an Englishman, Charles Wirgman (1835–91), a correspondent for *The Illustrated London*

News who had been living in Yokohama following the opening of the port in 1859. Although Wirgman was not a professional artist, he did paint in both oils and in watercolors, and he trained some well-known Japanese painters. The portrait of his Japanese wife Kaneko (Plate 3) is considered one of his best works. Her facial features are brought into clear relief from a dark recessed background by steady brushwork and a strong sense of form. Along with Fontanesi and Ragusa, the two Italian professors at the government-sponsored Technical Art School (to be discussed in the next chapter), Wirgman was one of the foreign artists most influential in the founding of Western art in Meiji Japan.

As the story goes, Takahashi commuted back and forth between Edo and Yokohama on foot, a distance

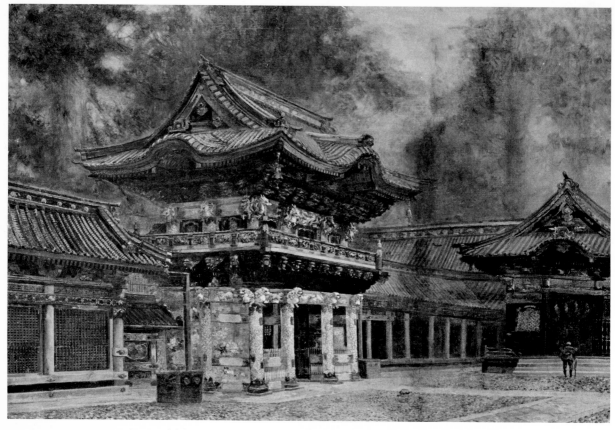

10. Soyama Yukihiko: Yōmeimon Gate at Nikkō. *Oil. c. 1890. Tokyo National Museum.*

of 19 miles, in his single-minded effort to learn more about Western art. Such devotion apparently took Wirgman by surprise, but the outcome of this enterprising effort was a remarkable improvement in Takahashi's painting technique. At about this time, a student sent abroad by the shogunate at the end of the Edo period, a certain Uchida Masao, returned to Japan with several Dutch oils and watercolors. Takahashi had access to these, and the opportunity to study original works undoubtedly reinforced his hardearned progress. It is against this background that *Salmon* must be understood: It is the fulfillment of a long, persistent struggle as well as a pioneering work of art.

Takahashi painted yet other still lifes in a similar style during the same period. They include such works as *Bean Curds* (Plate 5), *Half-Dried Bonito,* and *Drapery.* All demonstrate the artist's extraordinary ability to capture an object's texture and volume, even though as paintings they fall short of achieving the same intensity of expression conveyed in *Salmon.* It may be that there were times when even Takahashi was not able to free himself completely from the limiting ideas pervading early *yōga.*

Equal to *Salmon* in realistic conception, however, is the portrait of *Oiran* (Plate 6) painted, it is said, as a tribute to the rare hair style worn by the courtesan. In this painting as well, Takahashi transcends the level of merely documenting the external features of the model, and through a rather strange and forceful display of brushwork, brings out the brooding presence of the courtesan's inner character.

11. *Kunisawa Shinkurō:* European Lady. Oil. *1869–74.*
Tokyo University of Arts.

In addition to the paintings mentioned above, a number of Takahashi's landscapes survive. One work, *Cormorant Fishing on the Nagara River,* painted in 1877, deftly re-creates the atmosphere of a fishing scene, though the energy of the brushwork is much mellowed by contrast with that of *Salmon.* Generally speaking, these landscape paintings rarely surpass the level of old-style popular depictions of famous places. Furthermore, in contrast to the overall aura of composure and dignity that has settled over his still lifes and portraits, they seem to be a disappointing retrogression from the depth achieved in *Salmon.*

Along with furthering his own understanding of Western-style art, Takahashi was engaged in teaching the younger generation of *yōga* artists, as well as in popularizing Western art in Meiji society. Indeed, he

once explained that he chose the humble objects of daily life as his subject matter in the hope that they would attract popular attention and interest to this new art form.

In 1873, Takahashi established a private art school, the Tenkai-rō, which was soon renamed the Tenkai-sha. There, on the first Sunday of the month, his work and that of his students was publicly exhibited. The Tenkai-sha was once again reorganized, this time being called the Tenkai-gakusha, the name under which it operated until it was accepted as a licensed art school by the city of Tokyo in 1884. Takahashi's son Genkichi and Harada Naojirō studied there, as did Kawabata Gyokushō and Araki Kampo, both painters in traditional Japanese styles.

A discussion of Takahashi Yuichi would not be

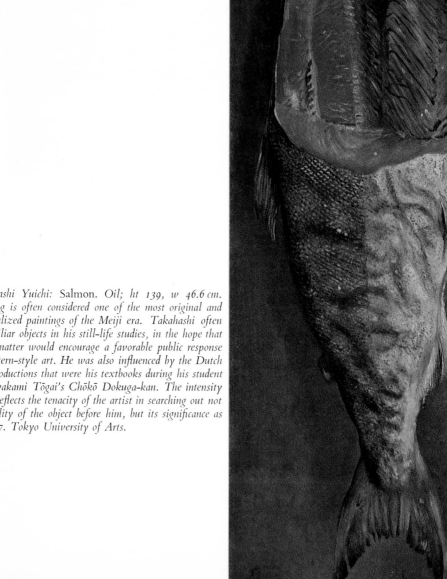

12. *Takahashi Yuichi: Salmon. Oil; ht 139, w 46.6 cm.*
This painting is often considered one of the most original and
and fully realized paintings of the Meiji era. Takahashi often
depicted familiar objects in his still-life studies, in the hope that
the subject matter would encourage a favorable public response
toward Western-style art. He was also influenced by the Dutch
still-life reproductions that were his textbooks during his student
days at Kawakami Tōgai's Chōkō Dokuga-kan. The intensity
of Salmon *reflects the tenacity of the artist in searching out not*
only the reality of the object before him, but its significance as
well. c. 1877. Tokyo University of Arts.

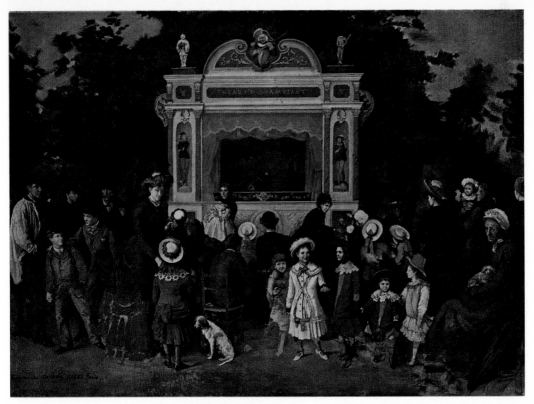

13. *Goseda Yoshimatsu:* Marionette Show. *Oil; ht 88, w 118 cm. Goseda was one of the first Meiji-era painters to study abroad. In this scene of a marionette show in a park in Paris, the artist focuses on the character of the audience, which is painstakingly depicted. Yet the details of dress, pose, and varying ages are woven into a coherent composition. The predominant use of dark, brownish colors reflects his early instruction from Antonio Fontanesi at the Technical Art School and the style of the Meiji Art Society. 1883. Tokyo University of Arts.*

complete without mentioning his role in advocating the publication of the first art journal in Japan and the establishment of an art museum, an institution as yet unknown in the rapidly modernizing country. Despite a lingering corner of conservatism in his concept of the civilizing and documentary nature of the pictorial arts for the purpose of advancing the nation, Takahashi's radical stand in developing his own style into a viable artistic expression is all the more noteworthy when compared with that of the other major painters, who had not yet conceived of Western art as anything but a practical tool.

Early Yōga Studios

Besides Tōgai's and Takahashi's studios, there were other private ateliers in Tokyo dedicated to the educa-

tion of Western-style painters. For example, Yokoyama Matsusaburō opened a studio in Shitaya Ikenohata in 1873; Soyama Yukihiko opened a studio named Daikō-kan; and Kunisawa Shinkurō started the Shōgidō in Kōjimachi in 1874.

Yokoyama (1834–84) was born on Iturup Island in the Kuriles and studied oil painting in Hakodate, Hokkaidō, under a Russian named Lehmann who was a correspondent for an illustrated paper. He then left this northern island of Japan for Hong Kong and the Dutch colonial city of Batavia (Jakarta), where he studied oil painting and photography. On his return to Japan, he opened a studio and taught photography and lithography at the national military academy. Among his students at the studio were Kamei Shiichi and Honda Tadayasu, both of whom developed into fine painters. His *Old Edo Castle* (Plate

9) shows his attempt to apply the principle of diminishing perspective as well as a serious effort to produce the precise size, shape, and weight of the castle. The work reveals the influence of the photographic realism that dominated many of the paintings of the time. Yokoyama's sense of realism was firmly rooted in his scientific orientation.

Soyama (1859–92), later known as Ono Yoshiyasu, left his birthplace in Kagoshima to study art under the Italian professors San Giovanni and Cappelletti at the Technical Art School. Later he was assistant professor of art at the Tokyo Imperial University School of Technology. He also opened his own studio, the Daikō-kan, which his followers Okada Saburōsuke, Wada Eisaku, Miyake Kotsumi, and Nakazawa Hiromitsu inherited after his death. The *Yōmeimon Gate at Nikkō* (Plate 10) was painted for the School of Technology in an unusual style that combines an overdone effort at capturing the physical likeness of complex architectural elements against a misty setting of soaring cryptomeria trees. The weakness of the painting lies in an imbalance between the technique of faultless perspective and the lack of artistic interpretation.

One of the first *yōga* artists to study abroad was Kunisawa (1847–77). A native of Kōchi, Shikoku, he was sent by his clan to England to study oil painting. He spent five years in London, where he studied under John Wilcom, and it was during this period that he painted *European Lady* (Plate 11) and several other figure paintings. Although this work is now in poor condition, there is still ample evidence of the serene expression on the woman's face. Laden with plaster models and art books, he returned to Japan to continue the work begun by Wirgman—training future *yōga* painters in Western techniques—and in this way contributed substantially to the development of *yōga*. Among his students at the Shōgi-dō were Honda Kinkichirō and Asai Chū, and it was Honda who later succeeded Kunisawa as director of the studio, which continued to produce outstanding artists. Asai, who studied under Kunisawa for one year, later became a leading figure in the *yōga* movement.

In the first decade or so of the Meiji era, Western-style painting did achieve some degree of popularity. The hard work and passionate enthusiasm of the early pioneers were major factors contributing to this momentum, but its success was favored by the times as well. The country was wholeheartedly embracing every facet of Western civilization in the spirit of the popular slogan *bummei kaika* (cultural enlightenment). In the wake of this indiscriminate acceptance of Western ideas, however, came an ultranationalistic reaction in the 1880s that was in bitter opposition to foreign influence and to the new generation of *yōga* painters as well.

2

Nationalism and Yōga: 1877–87

In an attempt to introduce Western art systematically, the Meiji government established the Technical Art School (Kōbu Bijutsu Gakkō) in November 1876 as part of the Technological College at Toranomon, Tokyo. The guiding principle of the school was the strictly utilitarian view inherited from the Bansho Shirabesho that Western art was a requisite skill for the development of industry and science. In other words, the Technical Art School was part of a government campaign to achieve equal status with the industrialized West as rapidly as possible. Despite its strongly utilitarian purpose, however, the school drew many students from private studios and other independent applicants who were simply eager to learn about contemporary Western art. The attraction was to a large degree the presence of three dedicated

teachers from Italy—Antonio Fontanesi, Vincenzo Ragusa, and Giovanni Cappelletti.

Fontanesi

The instruction offered at the Technical Art School was divided into three basic sections: preparatory studies taught by Cappelletti, sculpture under Ragusa, and painting under Fontanesi. The first, a well-known architect, taught the basic principles of geometry and perspective and also gave a course in the decorative arts. Ragusa gave instruction in clay and plaster modeling, and it was his students who were to initiate Western-style sculpture in Japan. Fontanesi, the oldest of the three and already a well-established landscape artist in Italy, taught painting and sketching.

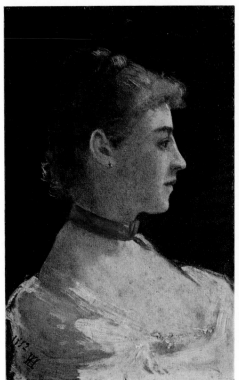 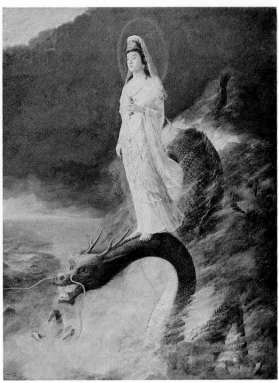

14. (left) Yamamoto Hōsui: European Lady. Oil; ht 41.1, w 33 cm. Yamamoto was one of Antonio Fontanesi's students at the Technical Art School before going to Paris to study under Léon Jérome. In the nine years he spent abroad from 1878 to 1887, he refined and developed his painting technique. This work, which was completed in Paris, is said to be the portrait of the daughter of the famous writer Théophile Gautier. 1882. Tokyo University of Arts.

15. (right) Harada Naojirō: Kannon Riding on a Dragon. Oil; ht 274.2, w 181.8 cm. The decade of the 1880s saw a revival of nationalistic fervor in Japanese society and presented artists with difficulties in choosing the proper subject for their paintings. As a result, many of the historical and imaginary paintings of the period were without substance in content and were mediocre as works of art. Here, however, a traditional religious iconographic subject is approached with new materials and perspective, and the painting is marked by an unusual intensity and uncommon softness in the handling of the brush. This work, which was exhibited at the Third National Industrial Fair in 1890, is strikingly different from the Shoemaker (Plate 16) that Harada painted three years earlier while in Europe. 1889. Gokoku-ji, Tokyo.

16. Harada Naojirō: Shoemaker. Oil; ht 50.5, w 46.5 cm. Harada studied in Munich under the historical painter ▷ Gabriel Max, and this early work, painted in Europe, clearly shows the influence of his teacher. Soft brushstrokes and dark shading have drawn out the likeness and the adamant character of the shoemaker. The psychological insight and precision in drawing that give depth to this portrait and to German Girl (Plate 28) stand in sharp contrast in approach and technique to his Kannon Riding on a Dragon, shown in Plate 15. The Kannon appears stylized and remote, so much so that it is difficult to believe both works were done by the same artist. The contrast between these two works is symbolic of the conflict within many of the artists of this period as they struggled to express themselves in an age buffeted by social change and inundated by new ideas. 1886. Tokyo University of Arts.

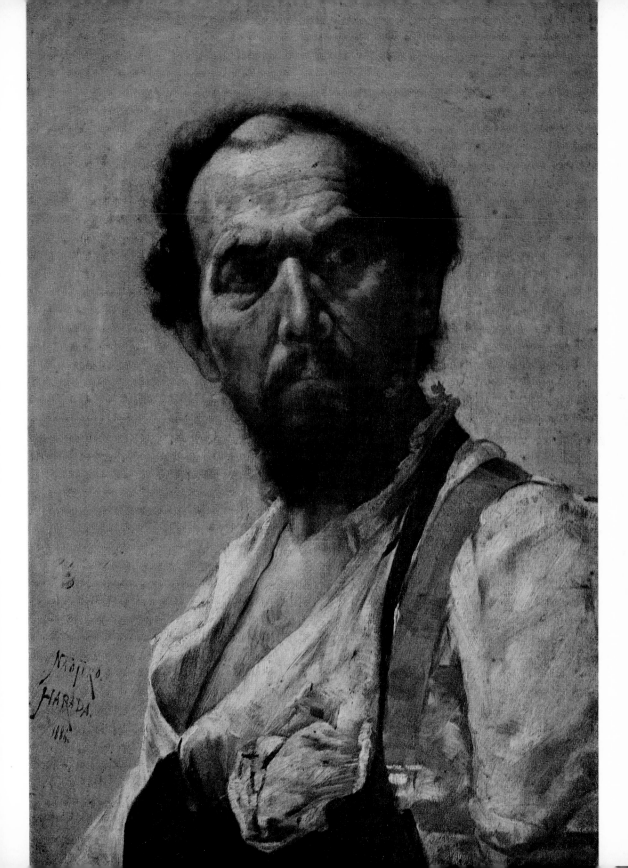

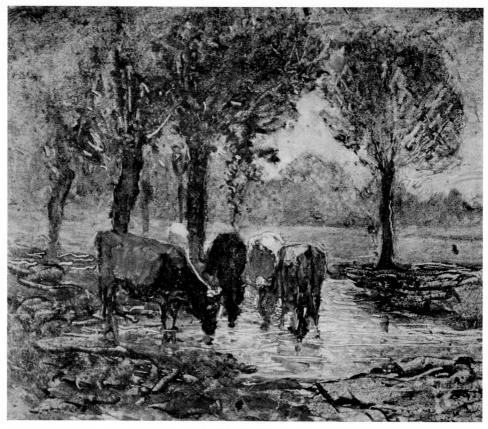

17. Antonio Fontanesi: Grazing Cattle. Oil. *1867. Tokyo University of Arts.*

A better teacher than Fontanesi could not have been chosen, for he was a man of great personal warmth and professional maturity. Born in 1818 in the northern Italian town of Reggio Emilia, he began his studies at a local art school and as a young man practiced decorative painting at home. With the rise of the Italian nationalist movement in 1848, however, Fontanesi, a passionate supporter of Italian unification, left his home for battle. Later, he was active as a landscape artist in Geneva, and occasionally traveled to Paris and London to perfect his skills. He admired the landscapes of the Barbizon school and also the work of Corot, and in particular linked himself with the styles of Daubigny and Ravier. He had become professor of landscape painting at the Royal Academy of Art in Turin when the invitation to teach in Japan reached him.

Fontanesi taught all aspects of painting at the Technical Art School: sketching from plaster-cast models in charcoal and crayon, pencil sketching from nature, landscape and figure painting in oil. This early group of students was the first in Japanese history to undertake the systematic study of oil painting, and of these, certain names stand out as important leaders of Western-style painting: Koyama Shōtarō, Matsuoka Hisashi, Nakamaru Seijūrō, Asai Chū, Yamamoto Hōsui, and Goseda Yoshimatsu.

Fontanesi's earnestness in his painstaking efforts to make his lectures understandable won him such great admiration from his students that when he was succeeded in 1878 by another Italian instructor who failed to live up to the standards he had set, eleven students, including Asai Chū, Koyama Shōtarō, Matsuoka Hisashi, and Takahashi Genkichi, withdrew from the

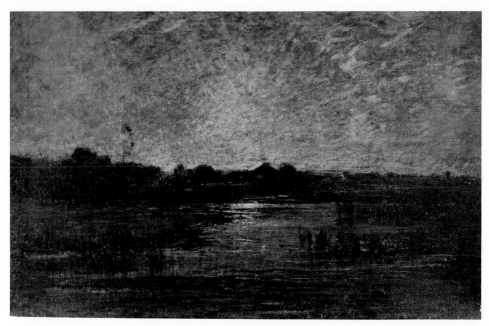

18. *Antonio Fontanesi:* Shinobazu Pond. *Oil. 1867–68. Department of Technology, Tokyo University.*

school in protest and formed their own study group, which they called the Jūichi-kai (Society of Eleven). Ill health had forced Fontanesi to return to Italy after only two years of teaching, but the impact he had made was to endure. Upon returning to Turin, he resumed his teaching position at the Royal Academy of Art until his death in 1881.

Several of the works Fontanesi took with him to Japan, as well as some he painted there, have survived the century. *Grazing Cattle* (Plate 17) and *Shinobazu Pond* (Plate 18) are dominated by his characteristic use of subdued colors, especially muted shades of brown, and also by a sweeping sense of mood and realism in his subject matter, unencumbered with minute detail. Each of his canvases, filled with a deep pastoral beauty and twilight tranquillity, conveys a mood of poetic contemplation that was absorbed by and con-

tinued in the works of his outstanding pupil, Asai Chū.

The new government art school was open for a short span of six years, closing its doors in 1883 for lack of funds and a waning morale. The Satsuma Rebellion of 1877, last of the civil wars subsequent to the Meiji Restoration, had drained the government's financial resources, and no one was able to fill the vacuum created by the resignation of Fontanesi. Furthermore, a strong reaction was growing in opposition to the flood of Western influence into Japan, and the Technical Art School was finally engulfed in a tide of nationalism and anti-Western hostility.

The Ultranationalist Reaction

The confusion of Japanese society at the time of the

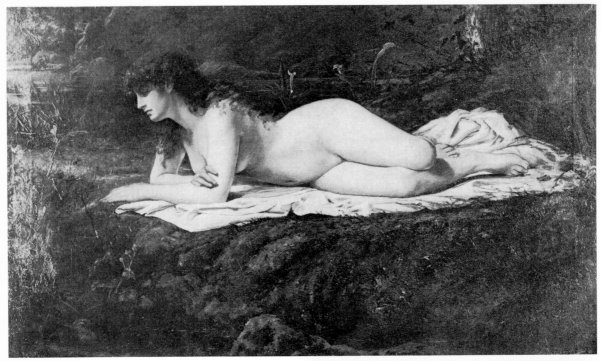

19. *Yamamoto Hōsui:* Nude. *Oil. c. 1882. Private collection.*

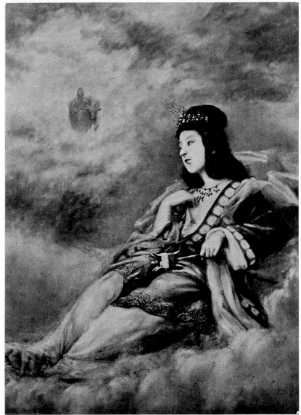

20. *Yamamoto Hōsui:* The Ox of the Zodiac. *Oil. 1892.*
Mitsubishi Nagasaki Dockyard.

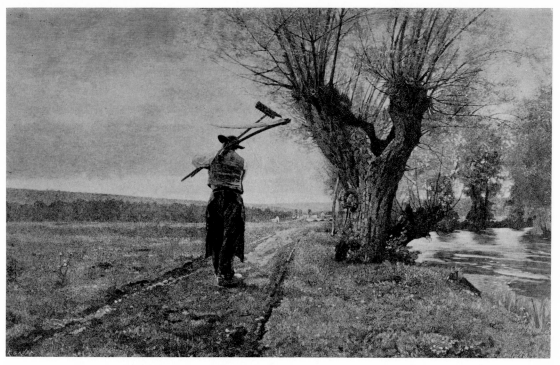

21. *Gōda Kiyoshi:* Day's End. *Woodblock print. 1886. Tokyo University of Arts.*

Meiji Restoration had been brought under control at least on the surface when the government turned its attention toward resisting the menace of the Western powers. The policy formulated to deal with the West had been created in haste and under the pressure of the immediate situation and met with excesses and contradictions in its enforcement. It had been one means of realizing the slogans of "prosperous nation, powerful military" and "increase production, promote industry." Under these extreme circumstances, a reaction was inevitable, and the decade that had opened under the banner of enlightened internationalism ended in the late 1870s in an introverted nationalistic fervor. In the arts, this trend was manifested in a strong emphasis on preserving the traditional arts at the expense of Western-style painting.

During the two and a half centuries of peace and national isolation of the Edo period, traditional painting schools had enjoyed the patronage of the shogunate, the imperial court, and wealthy merchants. These schools lost their direct source of support with the end of the feudal system and the radical social reorganization that followed the Meiji Restoration of 1868. With the exception of the Nanga school of literati art, a Chinese painting style that appealed to the new elite of the Meiji government, the oncoming wave of Westernization nearly destroyed traditional art. The favorable reception given the Japanese arts exhibited at the Vienna Exposition in 1873, however, stimulated a reevaluation and led to plans for the First National Industrial Fair of 1877 and for the inclusion of traditional arts and crafts among potentially exportable commodities.

In 1879 Sano Tsunetami, Kuki Ryūichi, and Kawase

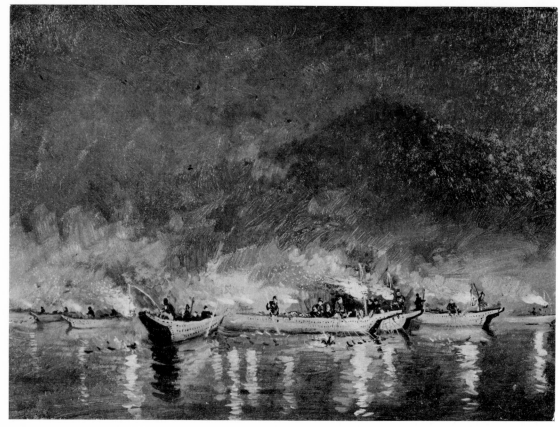

22. *Goseda Yoshimatsu:* Cormorant Fishing on the Nagara River. *Oil. 1878. Imperial Collection.*

Hideharu, leading figures in culture and education, organized a private art club, the Ryūchi (Dragon Lake) Society for the purpose of encouraging the waning traditional arts. One year earlier, a young American by the name of Ernest F. Fenollosa (1853–1908) had been invited to lecture on political philosophy at Tokyo University. An ardent admirer of Japanese art, Fenollosa was outspoken in his support of the drift toward conservatism in art. Addressing the Ryūchi Society in May 1882, he extolled the superiority of Japanese art over literati painting and deplored the very existence of Western-style painting in Japan. His words had far-reaching repercussions. In association with his student Okakura Tenshin (1862–1913), who was to become a major cultural leader, Fenollosa formed the Kanga-kai (Painting Apprecia-

tion Society) in 1884 for the promotion of a new Japanese art style.

The group held exhibitions, sponsored lecturers, studied old works, and offered encouragement to contemporary artists working in the Japanese tradition. Supported by the tide of ultranationalism, their hostility to Western-style painting, foreshadowed by Fenollosa's address, eventually came out openly. Western-style paintings were denied entry to the first two national painting competitions in 1882 and 1884, and in 1885 a bitter debate over art education in the elementary schools was waged between Koyama Shōtarō, a member of the Pictorial Research Committee of the Ministry of Education, and the conservative members of the committee. Koyama advocated adopting a program of pencil drawing in the elementary

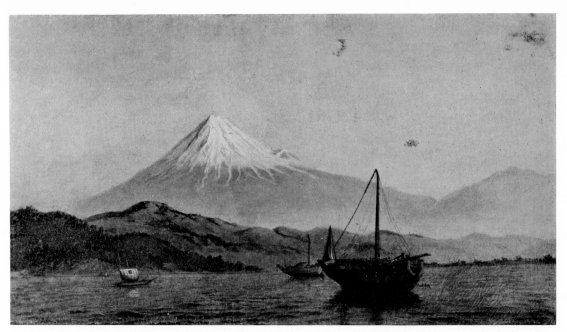

23. *Goseda Yoshimatsu:* View of Mount Fuji from Shimizu. *Oil. Tokyo Metropolitan Art Gallery.*

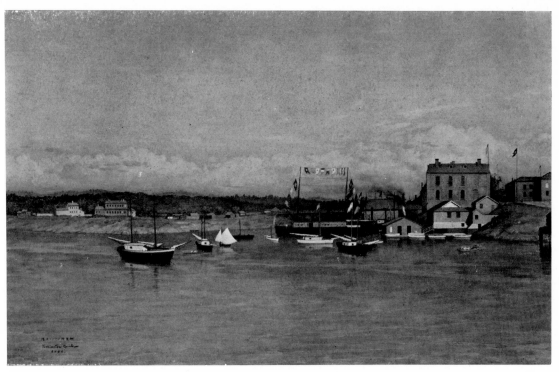

24. *Goseda Yoshimatsu:* View of Port Victoria, Canada. *Oil. 1892. Imperial Collection.*

25. *Watanabe Bunzaburō:* View of a Coast. *Oil. Tokyo National Museum.*

schools, while Fenollosa and Okakura remained firm in their demand that traditional brush and ink painting be taught.

Yōga in Transition

The future of *yōga* seemed suddenly insecure during the 1880s, but beneath these dismal prospects, the seeds for the next movement in Western-style painting were taking root. Asai and Koyama remained in Japan and continued their painting and teaching in the Western style, while other artists such as Yamamoto, Goseda, Matsuoka, and Harada left Japan to work in studios in Europe. Kuroda Seiki, a man of social distinction and the giant of Western-style painting in Japan in the latter half of the Meiji era, left for

Paris in 1884. It was persevering men such as he who would manage before long to revive interest in *yōga*. But other artists deserve mention as well for their efforts at renewing interest in the Western art form.

• YAMAMOTO HŌSUI (1850–1906). Among Fontanesi's students at the Technical Art School, Yamamoto was the first to study in Europe. His career as an artist began in Kyoto, where he worked in the *nanga* style. His interest in Western-style painting grew after seeing the work of Goseda Hōryū (father of Yoshimatsu), and soon thereafter he became his student. With the opening of the Technical Art School, he left Goseda to study under Fontanesi, and a year later went to France, where he had been accepted as a student of Léon Jérome. His use of rich oil pigments, as evidenced

26. Matsuoka Hisashi: Arc de Triomphe. *Oil. 1882. Tokyo University of Arts.*

in *European Lady* (Plate 14), portrait of the daughter of the writer Théophile Gautier, and *Nude* (Plate 19), a recent discovery that best represents his brushwork, makes his style a somewhat heavy one.

Besides earning a reputation for his accomplishments in painting, Yamamoto is also remembered for his role as mentor to Kuroda Seiki. It was he who recognized Kuroda's gift for painting while Kuroda was still studying law in Paris and encouraged him to pursue a career in art. After his return to Tokyo, Yamamoto, along with Gōda Kiyoshi, opened a studio which they called the Seikō-kan. It was later to be turned over to Kuroda, who renamed it Tenshin Dōjō and made it the center of the *plein-air* school.

Gōda (1862–1938), who collaborated with Yamamoto in establishing the Seikō-kan, went to France

at the age of eighteen intending to enter a program of agricultural studies. In Paris he shared a room with Yamamoto, who encouraged him to study woodblock printing instead, and once back in Japan, he taught woodblock printing at their studio and produced illustrations for textbooks and newspapers. For a while, he also taught French at the Tokyo Art School. *Day's End* (Plate 21), a woodblock print based on the original painting by Emile Adam, was shown at the government-sponsored exhibition in Paris and evokes a sense of solitude through subtle technique.

• GOSEDA YOSHIMATSU (1855–1915). As the son of an early Western-style painter, Goseda Hōryū, Goseda Yoshimatsu started his training at a young age; when he was eleven, he began instruction under Charles

27. *Matsuoka Hisashi:* An Italian Soldier. *Oil. 1886. Imperial Collection.*

28. *Harada Naojirō:* German Girl. *Oil. c. 1887. Tokyo National Museum.*

Wirgman. In 1874, his family moved from Yokohama to Tokyo, where they continued to paint and teach in their newly established studio. While yet a student at the Technical Art School, Goseda won the second prize in the First National Industrial Fair in 1877 for his *View of Mount Fuji from Shimizu* (Plate 23). No first prize was awarded in the competition, but both Takahashi Yuichi and Yamamoto Hōsui were awarded third place. In 1878 Goseda accompanied the emperor Meiji on a tour of various prefectures and painted some fifty landscapes (Plate 22), which he later presented to the emperor. In 1880 he left for France to study under Léon Bonnat, a noted painter of the Academy, and to copy selected works of old masters in the collection of the Louvre.

The best known of his canvases from France is

Marionette Show (Plate 13), painted in 1883. This animated scene of a park-corner marionette show and the surrounding audience is carried out with accuracy of form and an ingenious composition. The painting is, in fact, incomplete, but the careful identification and detailed description of a variety of figures, ranging from young children to aged faces, displays expert brushwork. Goseda's work never attracted much attention during his lifetime perhaps because he depended on the use of dark, somber hues usually connected with Fontanesi's Brown school, a style whose popularity waned as Impressionist techniques using light purplish shades became predominant.

Goseda passed through England and America en route home in 1889, and in the following year, he traveled to America accompanied by his father. The

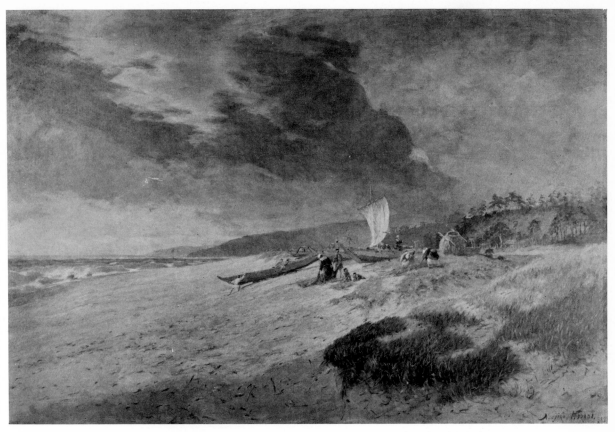

29. *Harada Naojirō:* Landscape by the Sea. *Oil. 1897. Tokyo University of Arts.*

theme for the *View of Port Victoria, Canada* (Plate 24), painted in 1892, was probably inspired by this voyage. The minute brushstrokes that form the buildings on the shore and the steamer at anchor are combined with broad, free ones to build up both sky and sea, and the entire composition creates an unmistakable feeling of depth. Goseda's personal weakness as a painter signals the flaw of Meiji Western-style painting as a whole— giving insufficient attention to the strength of the pictorial composition. Ill health prevented Goseda from painting after his return to Japan, and he died in obscurity.

One of Goseda's pupils at the Mukōjima studio, Watanabe Bunzaburō (1853–1936), began his career in *nihonga,* in the Maruyama school. Later he left his native Okayama for Tokyo to enter Goseda's studio,

where he met and married his master's sister Yūko, herself a Western-style painter. He taught art at Tokyo English School and was among the founding members of the Meiji Art Society, in whose shows he often exhibited. Unfortunately, his only extant works besides *View of a Coast* (Plate 25) are two watercolors, one a view of Mount Fuji and the other of a bell tower. Watanabe's skill as a draftsman is clearly seen in the strength of form built up through the energetic brushwork along the rocky coastline. After exhibiting at the first Pacific Painting Society exhibition and then at the first Bunten, the exhibitions sponsored by the Ministry of Education, he returned to Japanese ink painting and retired from *yōga* circles.

· MATSUOKA HISASHI (1862–1943). As a student of

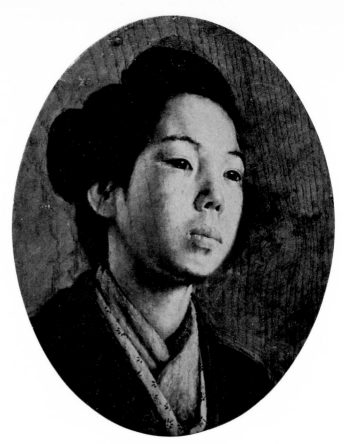

30. *Itō Yoshihiko:* Portrait of a Young Woman. *Oil. c. 1891. Kyoto City Art Museum.*

Kawakami Tōgai and later of Fontanesi at the Technical Art School, Matsuoka's style in his first paintings reflected the subdued resin colors characteristic of early Meiji *yōga*. However, following Fontanesi's resignation, he joined the Society of Eleven and soon after went to Italy to study at the National Academy of Art in Rome under Césare Maccari. There he adopted the bright and real-life modeling techniques of the academy. *An Italian Soldier* (Plate 27), done in 1886, is the clearest example of the techniques he absorbed while abroad. His careful eye for surface detail is revealed by the texture suggested in his interpretation of the soldier's face and uniform. *Arc de Triomphe* (Plate 26) evokes a pleasant color harmony and a contrast of spatial effects among the arch, the sky, and the trees. The way in which he has opened up a sense

of space moving into the canvas reflects his ability to arrange the elements of the scene before his eye.

Matsuoka returned to Japan in 1885 and in the following year joined in forming the Meiji Art Society. He held the title of professor at Tokyo Imperial University School of Technology, Tokyo Higher School of Industrial Arts, and Tokyo Art School until his death in 1943. Matsuoka's major contribution was in the field of art education rather than in painting, but the two works mentioned above are among the most outstanding Western-style paintings to emerge from the first half of the Meiji era.

· HARADA NAOJIRŌ (1863–99). Unlike the other artists, Harada did not attend the Technical Art School but graduated from the Foreign Language School in 1881.

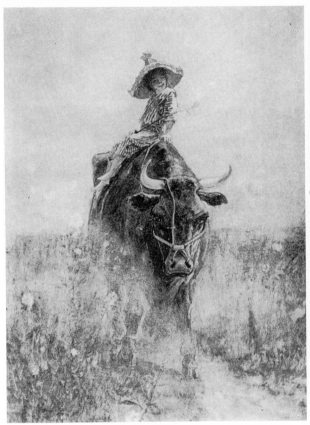

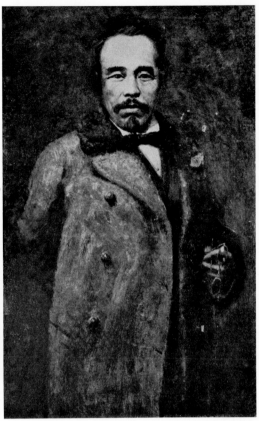

31. *Koyama Shōtarō:* Cowherd. *Watercolor. 1879–80. Private collection.*

32. *Koyama Shōtarō:* Portrait of Kawakami Tōgai. *Oil. c. 1877. Tokyo University of Arts.*

After studying Western-style painting under Takahashi Yuichi, Harada left for Germany to work under Gabriel Max, a historical painter in Munich. While living in that German city, he was befriended by Mori Ogai, the noted novelist, and became the inspiration for Kose, the Japanese artist in Ogai's novel *Utakata no Ki* (Story of a Transient Life).

Shoemaker (Plate 16), painted while in Europe, and *Kannon Riding on a Dragon* (Plate 15), done in 1889, are the most representative of Harada's works. What impresses the observer in the portrait of the shoemaker is the straightforward treatment of the model's appearance, the photographic representation of his facial features, the unhesitating flow of the brush, and the expert manipulation of light and shade. Here the artist tried to penetrate beyond the external appearance of

the man to his inner personality, while at the same time successfully drawing on the broad range of technical disciplines developed by the historical school to carry out his theme. The Kannon, painted only three years later, is a total reversal in subject matter as well as in technique. The surface texture is flat, and in contrast to the intensity of the shoemaker's expression, the Kannon seems cold and remote.

German Girl (Plate 28) conveys the purity of the young girl's character through a solid grasp of modeling and skillful use of color. The work also illustrates the artist's remarkable capacity to control the direction and application of the brush. Another of his works is *Landscape by the Sea,* illustrated in Plate 29. Harada returned home in 1887 to teach in his own studio, the Shōbi-kan, and to participate in the organizing of the

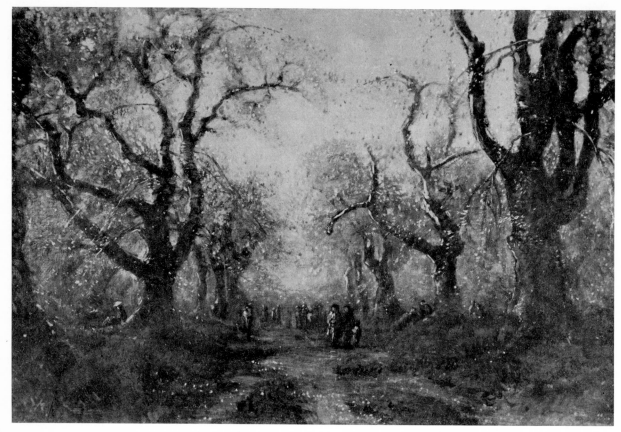

33. Koyama Shōtarō: Cherry Blossoms in Sendai. *Oil. 1881. Private collection.*

Meiji Art Society. His works, which were based on religious and mythical themes, drew a great deal of attention, but his health gradually began to fade, and he died at the age of thirty-six.

Among Harada's pupils at the Shōbi-kan was Itō Yoshihiko (1867–1942), a painter later active in the Kansai area. Following his graduation from Kyoto Metropolitan Art School, Itō went to Tokyo and received instruction from both Harada Naojirō and Koyama Shōtarō. In 1892 he returned to Kyoto to open his own studio, Shōbi-kai. *Portrait of a Young Woman* (Plate 30) is a product of his days at Harada's Shōbi-kan in Tokyo. The focus on the woman's luminous face is emphasized by her black hair, her navy-blue kimono, and her cinnabar-tinted scarf. The atmosphere of the work is still that of the early Meiji era.

Itō contributed to the founding of the Kansai Art Association and to the establishment of the Kansai Academy of Art headed by Asai Chū.

• KOYAMA SHŌTARŌ (1857–1916). Koyama's initiation into Western-style painting began during his enrollment in Tōgai's Chōkō Dokuga-kan. Shortly thereafter he transferred to the Technical Art School, where along with Asai Chū, he led the movement of dissident students to form the Society of Eleven. When the society later reached the point of establishing its own institute of art, Koyama and Asai joined the teaching staff. In 1877, the institute was named Fudō-sha, with Koyama as director. It continued to thrive until the end of the Meiji era, and evidence of its importance is the number of prominent artists it

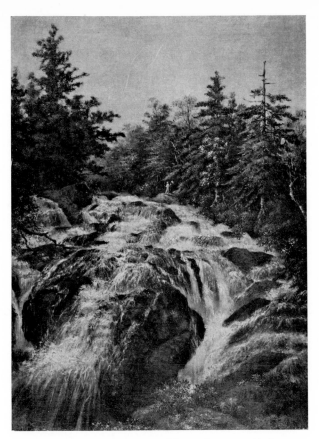

34. *Nakamaru Seijūrō:* Waterfall. *Oil. 1890. Bridgestone Museum of Art, Tokyo.*

helped to prepare, including Nakamura Fusetsu, Yoshida Hiroshi, Kosugi Misei, Nakagawa Hachirō, Aoki Shigeru, and Sakamoto Hanjirō. In addition to his affiliation with the Fudō-sha, Koyama also taught for many years at the Tokyo Teachers College.

Koyama's reputation was formed not only by his work as an educator, but also by his role as a spokesman in defense of Western-style painting in the face of the ultranationalism surfacing in the 1880s. His strong opinions were made public in two debates with Okakura and Fenollosa: that on art instruction in the primary schools in 1887 (cited earlier) and another five years before in 1882 in which he questioned the appropriateness of calling calligraphy a true art form. Koyama was undoubtedly a persuasive voice behind the organization of the Meiji Art Society.

Among his well-known works from the decade of the 1880s are *Cowherd* (Plate 31) and *Cherry Blossoms in Sendai* (Plate 33). These are valuable examples of the Technical Art School style in its formative years and amply reflect his acceptance of Fontanesi's teachings. The exaggerated depth perspective of the avenue lined with cherry trees illustrates how obsessed the early *yōga* painters were with creating illusionistic effects. In another work, *Portrait of Kawakami Tōgai* (Plate 32), Koyama reproduced the features of his first teacher, whose mission he faithfully carried out.

Other Yōga Artists

Nakamaru Seijūrō (1841–96), one of Fontanesi's outstanding pupils, began his training in Osaka in the

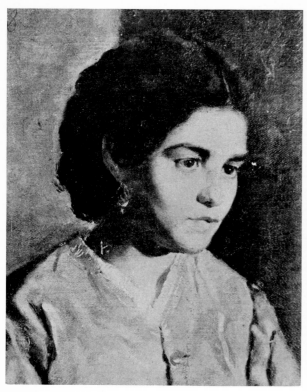
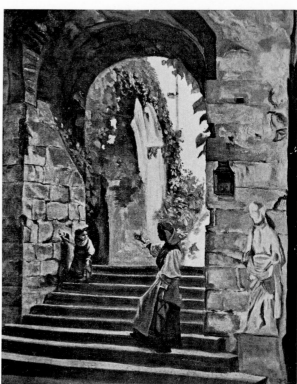

35. *Kawamura Kiyo-o:* Portrait of a Girl. *Oil. c. 1877. Tokyo National Cultural Properties Research Institute.*

36. *Hyakutake Kenkō:* Italian Scene. *Oil. c. 1880. Tokyo University of Arts.*

37. *Kawamura Kiyo-o:* Summer Airing. *Oil. c. 1890. Tokyo National Museum.*

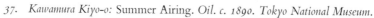

38. Hyakutake Kenkō: Bulgarian Woman. *Oil. 1879. Tokyo University of Arts.*

nanga tradition and later entered Kawakami Tōgai's Chōkō Dokuga-kan, where he turned to Western-style painting. As with so many of the early *yōga* painters, his style reveals a diligent effort at realistic depiction, as in his precision in defining the trees and rushing water in *Waterfall* (Plate 34). Nakamaru's strong point is that he managed to balance his eye for detail with a sense of the overall composition, a viewpoint that may reflect his earlier work in *nanga*. Nakamaru had his own studio, in which Fujishima Takeji and Oshita Tōjirō were among his students.

Born in Edo (Tokyo), Kawamura Kiyo-o (1852–1934) lived for a brief period in Osaka, where he trained in the *nanga* style under Tanomura Chokunyū. He returned to Edo to enter the Kaisei-jo, one of the successors of the Bansho Shirabesho, and to receive instruction from Kawakami Tōgai. In 1870 he traveled to America to study law, but took up art instead and then pursued his studies in France and Italy. On his return to Japan in 1881, he set up his own studio, where he taught the luminous brushwork characteristic of Italian painting. *Portrait of a Girl* (Plate 35) was probably done while he was studying at the Venice Art Academy and is marked by a bright color harmony and delicate brush technique that evokes the youth of his model. *Summer Airing* (Plate 37) is another example of Kawamura's work before he went back to a more Japanese style of painting and finally dissociated himself completely from the art world.

Hyakutake Kenkō (1842–87) was an artist by avocation, though not of amateur level. He spent his life as a career diplomat and in that capacity in London

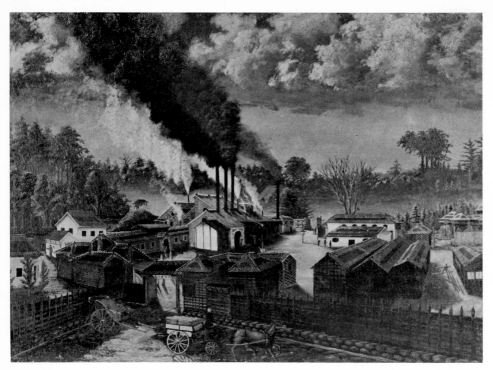

39. *Tokonami Seisei:* Mita Paper Mill. *Oil. 1880. Paper Museum, Tokyo.*

was able to study painting under Richardson. Later in Paris he worked under Léon Bonnat, and in Rome under Césare Maccari. *Bulgarian Woman* (Plate 38) portrays a young woman in folk costume whose features are evoked with dramatic use of chiaroscuro and contrasting colors balancing the white of the blouse, the red fruit in her hand, and the red printed apron. Not being a professional painter, he left no followers, but he did assist Matsuoka Hisashi while he was studying in Rome and inspire Okada Saburōsuke, who like Hyakutake hailed from Saga Prefecture in central Kyūshū, to take up Western-style painting.

Another amateur painter, but a self-styled one, was Tokonami Seisei (1842–97). He was born in Kagoshima and first came in contact with Western-style painting on board a British warship moored in Nagasaki. Later, he began teaching himself Western-style painting while working as a public procurator in Sendai. In the *Mita Paper Mill* (Plate 39), there is a primitive charm in his haphazard choice of the objects in the scene and a conscientious effort to render exactly what the eye sees. He painted several other canvases in the same naive style of exaggerated perspective and unorganized composition, but *Mita Paper Mill* is considered to be his best work.

3

The Meiji Art Society: Asai Chū

Western-style painting gradually began to show signs of revival toward the end of the 1880s following the decade of decline under the criticism of the ultranationalist movement. Two factors in particular helped open the way for its revival. One was the return from Europe of several major artists fresh with the momentum of their European experience; the other was the instruction in Western-style art that had quietly continued during this period in the Society of Eleven and other private art schools in Tokyo. Also to emerge from this renewed interest in *yōga* was the first national art association of Western-style painters, formed in 1889, which became known as the Meiji Art Society (Meiji Bijutsu-kai). Convinced that theirs was the art for a new age, the Western-style painters were now prepared to challenge the dominant position of the new Tokyo Art School, which had been founded two years earlier by Okakura, Fenollosa, and other exponents of traditional art. The Tokyo Art School specifically excluded Western-style art from its curriculum.

The Meiji Art Society

The Meiji Art Society elected as its president Watanabe Kōki, president of Tokyo Imperial University; its directors were the politician Hara Takashi and the banker Iwashita Seishū; and those invited as patrons were other influential leaders of Japanese society known to be sympathetic to the *yōga* movement. Its own promoters, Asai, Koyama, Harada, Matsuoka, and Kawamura, prepared an opening exhibition in

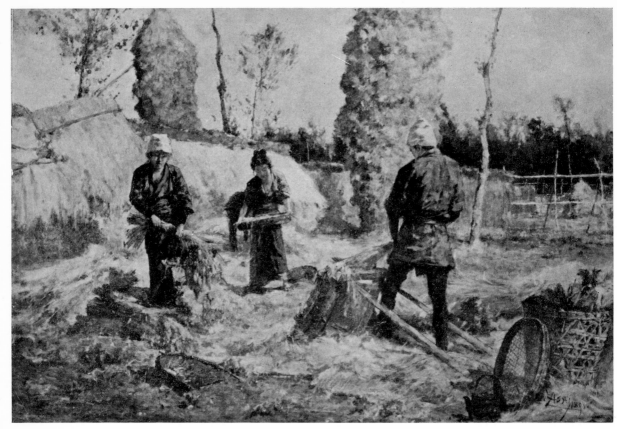

40. Asai Chū: Harvest. Oil. 1890. Tokyo University of Arts.

Tokyo in the fall of 1889 in which 119 representative works were shown at a racetrack near Shinobazu Pond in Ueno Park. The paintings were well received by the public, and the exhibition was considered to have been a fairly successful venture. A second exhibition, held at Peers' Hall in Ueno Park the following autumn, presented 141 original works by Japanese artists as well as some 80 works by European artists, including Daubigny, Millet, and Degas. The latter won as much popular acclaim as the paintings by Japanese artists. Following this successful debut, Western-style painters, overriding stiff opposition raised by the ultraconservative faction, were finally permitted to exhibit their works at the Third National Industrial Fair in the spring of 1890. It was this event that finally secured the return of *yōga* to public recognition.

The actual examples of *yōga* paintings produced during this period, however, are admittedly of disappointing quality taken as works of art. Artists consistently drew upon a variety of historical or imaginary themes that were then rendered on the level of narrative or illustrative pictures. In figure and landscape painting, artists were so preoccupied with the exact reproduction of external forms that the compositions were generally formal and wrung dry of any sense of spontaneity. It is indeed a strange turn of events that these Western-style painters, who claimed to be bearing the standard of a new era of art, ultimately fell back on themes one would surely have expected them to reject. Their understanding of the meaning of realism in art had actually not advanced much beyond that of their immediate predecessors, who had

41. Asai Chū: A Washing Place. Oil. 1901. Private collection.

maintained that oil painting was simply a useful technique, a practical skill rather than an expressive art form.

The confusion facing the *yōga* painters at this juncture is perhaps best summarized in the contents of a lecture delivered by Toyama Shōichi, professor at the Tokyo Imperial University, at a meeting of the Meiji Art Society in 1890, a lecture that provoked a series of debates on the question of subject matter appropriate for Western-style painting. Professor Toyama maintained that it was anachronistic for these artists to persist in painting religious themes in an age which had generally cast off religion; the future of Western-style art in Japan lay in creating a style that would fully reflect the affairs of men. Toyama singled out historical motifs as most appropriate and cited three

examples as possible subject matter: the highly emotional deathbed scene of Toyotomi Hideyoshi as he meets for the last time with his favored general, Tokugawa Ieyasu; the tomb of the twelfth-century military ruler, Minamoto Yoritomo, quietly gathering moss by a hillside overlooking the distant Pacific; and the scene of an impoverished family on the verge of throwing their infant into the moonlit Sumida River.

Hayashi Tadamasa, a wealthy Tokyo art dealer, countered with the argument that the real issue before Western-style painters was not one of ideology, but rather one of developing the techniques to convey their ideas effectively. The debate reached an audience beyond the scope of the art world, eliciting comments from literary circles, and from the novelist Mori Ogai in particular. No concrete solutions emerged from the

42. Asai Chū: Poplars in Grez. *Oil. 1901. Tokyo National Museum.*

discussion, but the controversy served to expose the lack of direction among *yōga* artists at that time. As early as 1891, after only its third annual exhibition, the Meiji Art Society had begun to show signs of disintegration; and with the introduction of the new theories of the *plein-air* school as brought by Kuroda Seiki upon his return from France, its style was soon labeled passé and faded into obscurity.

Another observation concerning the work of this period is that the artists returning from sojourns in Europe, some of whom became pillars of the Meiji Art Society, had, in fact, created remarkably substantial works while abroad but produced uniformly mediocre paintings on their return—almost as though their brushwork, which had found new energy in Europe, was stunted once within the familiar boundaries of Japan. The dearth of free expression in Japan was not simply a symptom of this particular period, but seemed to reaffirm the basic problem that *yōga* was a transplanted rather than an indigenous artistic expression. The tendency of these artists to re-create historical subjects recalls the pressures of a decade earlier that had forced *yōga* as a whole to take a conservative stand. One exception is the *Kannon Riding on a Dragon* (Plate 15) by Harada Naojirō, shown at the Third National Industrial Fair, which combined with some degree of success a traditional subject and contemporary technique. Despite Toyama Shōichi's comment that it reminded him of a "circus woman walking a tightrope by torchlight," the Kannon and the dragon gliding over the dark water, painted in careful brushstrokes, exude a peculiar surrealistic intensity.

43. *Asai Chū:* Trees in Winter. *Watercolor. 1903. Tokyo National Museum.*

The other outstanding exception to the general feeling of stagnation was the work of Asai Chū. His *Spring Furrows* (Plate 48), shown at the first Meiji Art Society exhibition, and *Harvest* (Plate 40), shown at the second, indisputably rank among the very finest products of the century-old tradition of modern Western-style painting.

Asai Chū

Asai (1856–1907) was born in the Edo mansion of the Sakura clan as the first son of the samurai Asai Iori. Following the deaths of his grandfather and father, he succeeded to the position of head of the family at the age of seven. He was then taken to the clan home in Shimofusa Province (modern Chiba), entered the clan school the same year, and at the age of nine began taking lessons from an artist of the Nanga school. His gifts were soon apparent. Asai's skills were not limited to the area of fine arts, but extended as well to such martial arts as fencing and horseback riding, both prerequisites for his destined role as a samurai.

In 1872, Asai set out for Tokyo to attend a school for English-language studies. However, his desire to be a painter grew increasingly stronger, and within three years, despite opposition from his family, he entered Kunisawa's studio, the Shōgi-dō. The following year, he entered the Technical Art School to become a student of Fontanesi.

Asai's sensitivity, nurtured during his youth in the quiet countryside, away from the turbulent changes wrenching the capital city, seems to have responded

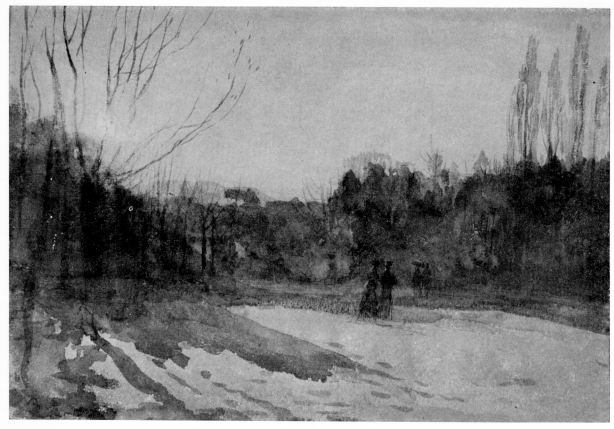

44. *Asai Chū:* Setting Sun. *Watercolor. 1901. Tokyo National Museum.*

naturally to Fontanesi's elegiac style, which was de-
rived from the Barbizon tradition. This is quite obvi-
ous in the sketches he produced at the Technical Art
School, which capture the sweeping, overall mood of
a scene in soft, descriptive outlines unencumbered
with detail.

During his association with the Society of Eleven,
which spanned the years of ordeal for *yōga* artists,
Asai poured his efforts specifically into developing his
drawing skills and paid little heed to the vicissitudes
charging the atmosphere of his day. *Spring Furrows*
and *Harvest* remain as the fruits of this concentrated
effort to cultivate and polish his own style.

Spring Furrows (Plate 48) is a rural scene of early
spring in which a family of farmers is at work hoeing
the furrows of a wheat field. The figures are sheltered
in a setting of bare trees and thatched roofs, which

combine to make a simple scene, unassumingly drawn.
At the same time, the painting clearly conveys the
pleasantly chilly air of spring and the humble atmos-
phere of the Japanese countryside.

Typical of Asai's compositional sense, the organiza-
tion of the painting recedes from a foreground of dark
greens touched with shades of brown, into a middle
plain of lighter coloration, and finally into an area
of unbounded space. Light dashes of pigment round
out trees, the postures of farmers at work, and the
abbreviated contours of the trees lining the middle
ground. The painting is one in which the warmth
and intimacy of Japan's natural setting is captured
through the keen eye of the artist, a fine example
of modern Japanese realism but indistinguishable in
its aesthetic attitude from European prototypes of
the mid-nineteenth century.

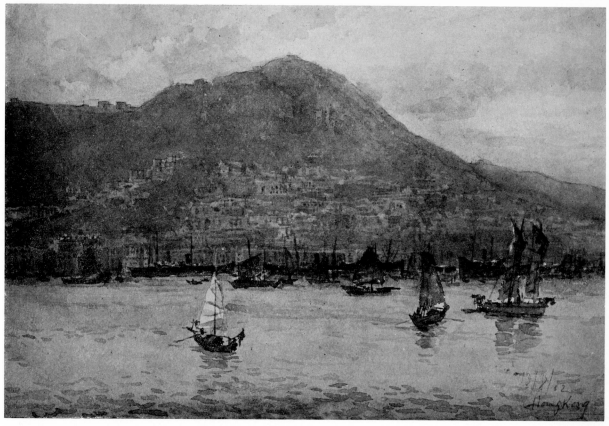

45. *Asai Chū:* Hong Kong Harbor. *Watercolor. 1902. Tokyo National Museum.*

Harvest (Plate 40) is a pastoral scene of farmers in the fields threshing rice under an autumn sun. Its mood communicates a sense of peace and tranquillity. What one notices immediately is that Asai's brush flows more freely in this painting, while his composition is more complex and thus less intense as a whole than that of *Spring Furrows.* The area receding from the farmers at work in the foreground to the trees in the back is touched with the brisk atmosphere of autumn, and the painting reflects a mood of total calm.

Compared with other contemporary Japanese work, these two paintings by Asai stand out because of their freshness and originality first, in the unorthodox choice of subject matter, and second, in the superior quality of expression. Asai's work always reflects Fontanesi's early influence, but it was his own profound search

for individual expression, reinforced by the instruction he received at the Technical Art School, which led him to realize that ultimately only his own eyes and sensitivity could provide him with inspiration for his expression.

When in 1893 Kuroda Seiki introduced the luminous palette of the French *plein-air* artists who painted nature in outdoor light, a rivalry sprang up dividing the new group of men rallying around Kuroda from the artists of the Meiji Art Society, who clung tenaciously to their former style. Asai, though he was credited with being the leader of the conservative group, simply detached himself as much as possible from the feud and steadily pursued his own work.

When the department of Western-style painting was finally created in 1896 at the Tokyo Art School, thereby reversing the earlier policy, Kuroda and other

46. *Asai Chū:* Autumn in Grez. Oil; ht 79.1, w 60 cm. The ▷
*work done by Asai during his stay in France is of uniformly high
quality, and this is the most famous of his poplar paintings. The
scene is the corner of a meadow in Grez-sur-Loing on the out-
skirts of Paris, where Asai and other Japanese artists in Paris
often went to paint. The serene atmosphere of late autumn lingers
through the bare branches of the poplar trees and the delicately
colored leaves scattered on the ground. Asai's depiction of light and
shade show the strong influence of Impressionist techniques and
approaches, as well as the depth of his grasp of a totally new way
of portraying the world. 1901. Tokyo National Museum.*

plein-air artists were called in to fill the new posts on
the faculty. Two years later, when a place was also
created for the Meiji Art Society, Asai Chū was in-
vited to join the teaching staff as a representative of
that group. The *plein-air* artists, however, kept a firm
hold on the school, making Asai's position somewhat
uneasy. When in 1900 he was sent by the Ministry of
Education to study in France, he was given a welcome
opportunity to end his association with that institu-
tion.

Asai's devotion to his work during the two years
in France was almost feverish. Perhaps it was the sud-
den release from wearisome entanglement in the feud
between the new and old schools in Tokyo that un-
shackled his powers of creativity and stimulated him
to produce at a faster pace. The bulk of his work during

this period, both in oil and watercolor, was done at
Grez-sur-Loing in the suburbs of Paris. *Autumn in
Grez* (Plate 46), for example, depicts the corner of a
deserted meadow with a few poplar trees. An autum-
nal atmosphere and sense of serenity permeate the
canvas through the still-green grass covered with fallen
leaves and the half-naked branches of poplar trees. In
the carefully placed color tones and detailed brush-
work, it is a fine example of how Asai adapted Im-
pressionist techniques to his own style.

A Washing Place (Plate 41) is a view of rustic
laundry sheds located by a forest stream. The verdant
scene seems to have appealed to Asai's poetic senti-
ments, for the colors are thickly built up and the space
and depth of the canvas are determined by shading
through subtle gradation of color tones. All these de-

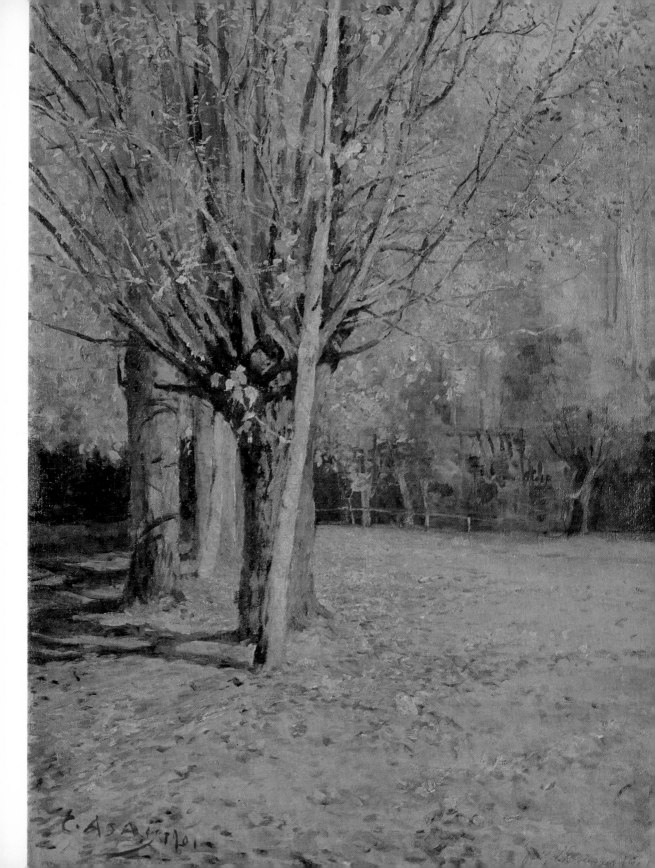

tails make it a memorable work, despite its small size. In addition to these, *Poplars in Grez* (Plate 42) and *Willow Trees in Grez,* both in oil, as well as two portraits, *Woman under a Tree* and *Reading,* were completed during his stay in Grez.

While in Paris, shortly before returning home to Japan, he completed a canvas entitled *Sewing* (Plate 49). What is distinctive in this painting is the newly found openness of his brushstrokes that makes it the best among his portraits painted in France. Vivid contrasts are created between the brightly colored cloth the woman is holding, her shawl, and her dress, while from the flow of the strokes, we can almost imagine the atmosphere of her surroundings and life.

Asai was very fond of watercolor and produced a good number of paintings in this medium throughout his life. His best works include *Trees in Winter* (Plate 43), *Setting Sun* (Plate 44), and *Bridge in Grez,* all done during his sojourn in France. The soft tones of the liquid medium applied with genuine mastery impart a poetic touch to these paintings.

On his return from Paris in the summer of 1902,

Asai joined the faculty of the Kyoto Industrial Art School as professor, a position he had been offered while in France. He was an affiliate of the Kansai Art Association and presided over the Kansai Academy of Art (both of which centered their activities in the Kyoto-Osaka district) until his death in 1907. Umehara Ryūzaburō, Yasui Sōtarō, Kuroda Jūtarō, and Tsuda Seifū, names well known in contemporary Japanese art, all studied under Asai at the Kansai Academy of Art.

It is in retrospect that Asai's realism, deeply rooted in Japanese soil, is highly regarded and valued today. *Yōga* artists in the years following Kuroda's return to Japan and leadership in Western art circles, however, did not respect his example. He was brushed aside as outmoded; the focus of the art world was fully directed toward the *plein-air* school. Unfortunately, the total neglect of Asai's understanding of realism was a severe setback for Western-style painting, for his sense of discipline would have provided the strong foundation in artistic principles so necessary for the next generation of artists.

◁ 47. *Asai Chū:* In Port Arthur after the Battle. *Oil. 1895. Tokyo National Museum.*

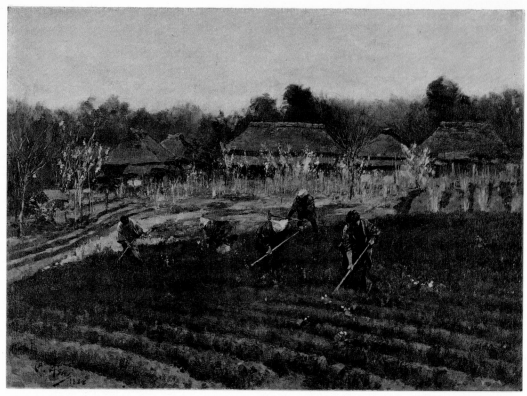

48. *Asai Chū:* Spring Furrows. *Oil; ht 56, w 74 cm. This intimate scene of a farming village reflects Asai's own quiet dialogue with nature and illustrates his accomplished sense of tight composition; the planes are worked from front to back through strong diagonal lines in the furrows to a stable horizontal middle plane of flowering trees, and finally to an open plane of infinite sky. Asai trained first in Tokyo under Antonio Fontanesi in the style of the Barbizon school, but as is evident in this painting, he later developed his style into one reflecting a distinctly Japanese awareness. 1889. Tokyo National Museum.*

49. *Asai Chū:* Sewing. *Oil; ht 60.4, w 55.2 cm. After leaving Grez, Asai returned to Paris and stayed there a little over a month before returning to Japan. During this short stay, he painted this work of his concierge's wife sewing. The color contrast of her blue skirt, multicolored shawl, and white cloth is extremely effective, and his brushstrokes have a rhythmic quality. The newly found openness of his brushstrokes distinguishes this painting as the best among his portraits painted in France. 1902. Bridgestone Museum of Art, Tokyo.* ▷

Mars 1902

4

The Plein-Air School: Kuroda Seiki

As first-generation Meiji Western-style artists, Tō-gai and Takahashi Yuichi spent their lives attempting to break down prejudices against Western art in order to build it up as a valid artistic expression. In the following generation, one artist, Kuroda Seiki (1866–1924), launched the *yōga* movement from the current stream of art in Europe by bringing to art circles in Japan the techniques of *plein-air* realism. *Plein-air* was never a formal school of art in Europe but rather a term used to describe paintings done in natural outdoor light. His use of bright, luminous colors copied directly from nature was a radical change from the soft browns and dark canvases that Japanese students at the Technical Art School had been producing under Fontanesi's influence.

The Tenshin Dōjō

The techniques Kuroda used were based on the instruction he received during his two-year residence in Paris studying under Raphael Collin, an eclectic painter who combined the clear representational forms of the classical school with the chromatic principles of impressionism. Collin specialized in depicting the human figure in open-air settings, drawn in graceful poses. Under Collin's instruction, Kuroda matured rapidly as a painter, going much more deeply into the style of the Impressionists than did his teacher. While yet a student in Paris, he achieved his ambition of being elected to the French Salon, the official exhibitions of the government-sponsored Academy.

50. Kuroda Seiki: By the Lake. Oil. 1897. Tokyo National Cultural Properties Research Institute.

During the ten years Kuroda spent in France, significant events were unfolding in Paris art circles: Van Gogh, Bonnard, and Toulouse-Lautrec became acquainted; Gauguin and Seurat were exhibiting their works; Cézanne was active as well; and the Symbolists were gathering at the Café Voltaire. These were the years when the Impressionists had realized their vision in painting, and other artists were already beginning to use their theories as a point of departure into entirely new directions. Kuroda, in his involvement in Parisian art and social circles, must also have basked in this creative atmosphere.

Kuroda returned to Japan in 1893, and his message to the art world was a milestone in the careers of young painters. Bearing the standard of the artistic

revolution sweeping the Paris art circles and the honor of his election to the Salon, he gathered around him the younger artists of the Meiji Art Society, by then disillusioned and tired of the older style, yet lacking the impetus to free themselves from it.

While still abroad, Kuroda had submitted several works to the exhibitions of the Meiji Art Society, and through them his name became known to the public. Despite his reputation, however, his paintings aroused little more than simple curiosity. But his appearance on home soil and the quality of the large number of works he had completed abroad were to inspire a whole new direction in Meiji-era *yōga*. During his years in Paris, Kuroda had enjoyed the free atmosphere of French art circles and tasted the bohemian

51. *Kuroda Seiki:* Reading. Oil; *ht 98.2, w 78.8 cm. Here, a young girl of Grez, the daughter of Kuroda's landlord, is reading by the light streaming in through the slats of the louvered window. The painting, which was selected for exhibition at the official French Salon, was one of Kuroda's first after he made the decision to abandon his legal studies. 1901. Tokyo National Museum.*

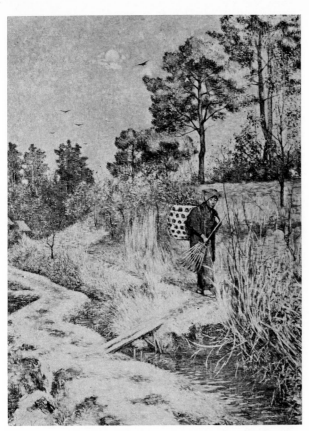

52. *Kume Keiichirō:* Autumn Landscape. *Oil. 1895. Tokyo National Museum.*

life; it was an ambiance in sharp contrast to the feudalistic system that governed art circles in Japan. Within a year of his return, Kuroda took over Yamamoto's studio, the Seikō-kan, renamed the Tenshin Dōjō, in partnership with his friend and roommate in Paris, Kume Keiichirō (1866–1934). The atelier was christened Tenshin Dōjō by Kume's father, a noted scholar, after the phrase *tennen shizen no mama,* which implies seeing visual nature through the eye of one's own pure nature or intuition, and aptly expressed the aesthetic view of Kuroda and Kume.

The principles that Kuroda and Kume taught their students may seem outmoded to the contemporary reader, but they were the ultimate in modern instruction at that period. Representative of Kuroda's idea were dictums such as "students in this studio must strive toward *tenshin* [innocence and directness toward nature]"; or, "figure study shall be learned through objective drawing from plaster casts and human figures." The quality of *tenshin* that Kuroda urged upon his students was, in fact, an unrestrained search for individual expression reaching beyond all former limits.

As a principle of teaching, this had a dramatic effect on young artists who were all more or less bound by tradition to the feudal-style teacher-apprentice relationships and the highly disciplined spirit of craftsmanship that had controlled the arts throughout the Edo period. Especially exciting was the immediacy of sketching the human form from live models, a practice Kuroda introduced while the established *yōga* studios were still following the Italian tradition of drawing from plaster-cast models with pencil and pastels. The new and radical principles on which the

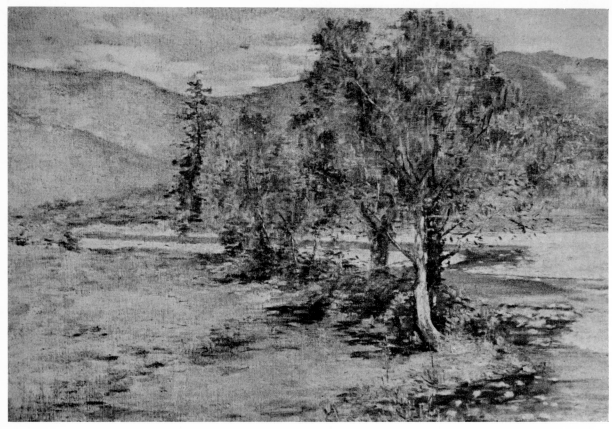

53. Kume Keiichirō: Kamo River. Oil. 1894. Tokyo University of Arts.

studio based itself were a great attraction to young painters, and many of those who joined, such as Fuji-shima Takeji, Okada Saburōsuke, and Wada Eisaku, were later to become famous artists in their own right.

Kume Keiichirō and Kuroda Seiki shared a long friendship beginning while they were both in France and continuing through their mutual experiences at the Tenshin Dōjō, the Tokyo Art School, the White Horse Society, and the Bunten exhibition that later dictated the *yōga* trend. Kume continued painting for quite a while after returning to Japan, but his later activities centered more around art education and administration as Kuroda's partner. He was born in Kyūshū and pursued his art studies in Tokyo under Fuji Masazō until leaving for France in 1886, where through Fuji's introduction he entered Collin's studio.

It was there that he met Kuroda for the first time. His *Autumn Landscape* (Plate 52) and *Kamo River* (Plate 53) are quite clearly influenced by the *plein-air* technique. These scenes are set in bright outdoor light, but the composition is simpler and the tone milder than that of the style set by Kuroda.

Kuroda's encounter with Collin in Paris largely determined the path that Japanese Western-style painters were to take. The style he learned and subsequently transplanted onto Japanese soil was not necessarily the impressionism we recognize as early twentieth-century art, but rather a diluted version of *plein-air* realism which thenceforth came to be accepted among the Japanese painters as orthodox impressionism. The consequence of accepting Collin's teachings as orthodoxy was that later generations were left the responsibility of correcting this misconception.

54. *Fuji Masazō: French Landscape. Oil. c. 1890. Tokyo National Museum.*

In his style of *plein-air* realism, Collin did not pursue in depth the theories of natural light that had absorbed the thinking of the Impressionists. His eclectic style was in fact lacking in a solid grounding in Impressionist writings, which may explain why he is almost totally unknown today. Nonetheless, from the perspective of nineteenth-century Japanese Western-style painting, his style was still new and fresh, particularly his concept of using light colors rather than the sober resin tones characteristic of the earlier *yōga* painters. Thus, paradoxically, Collin's style, which passed rapidly from Kuroda to his students, was understood to be French impressionism.

Collin's influence on *yōga* is sometimes considered an unfortunate development for which Kuroda, perhaps unknowingly, was responsible. The fundamental issue facing *yōga* of this period was not the degree or quality of Collin's influence on Kuroda, but rather the fact that the Japanese *plein-air* school was itself caught up in the complex problems of social and political change of the Meiji era. In the process, it lacked depth in content and organization in very much the same way as the entire late nineteenth-century modernization movement, for both had been established impetuously and without adequate thought or preparation.

The Purple-Brown Controversy

The *plein-air* techniques taught by Kuroda at the Tenshin Dōjō met with immediate success and gained momentum rapidly. Kuroda and other members of the *plein-air* school became members of the Meiji Art Society and each year submitted a large number of

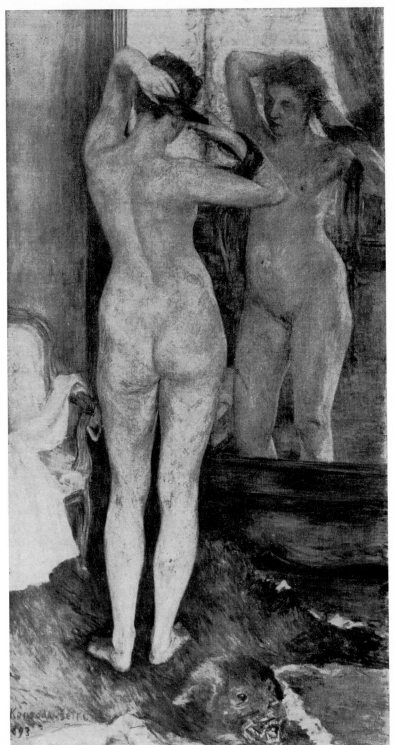

55. *(opposite) Kuroda Seiki:* Woman with a Mandolin. *Oil. 1890. Tokyo National Museum.*

56. *Kuroda Seiki:* Morning Toilette. *Oil. 1893.*

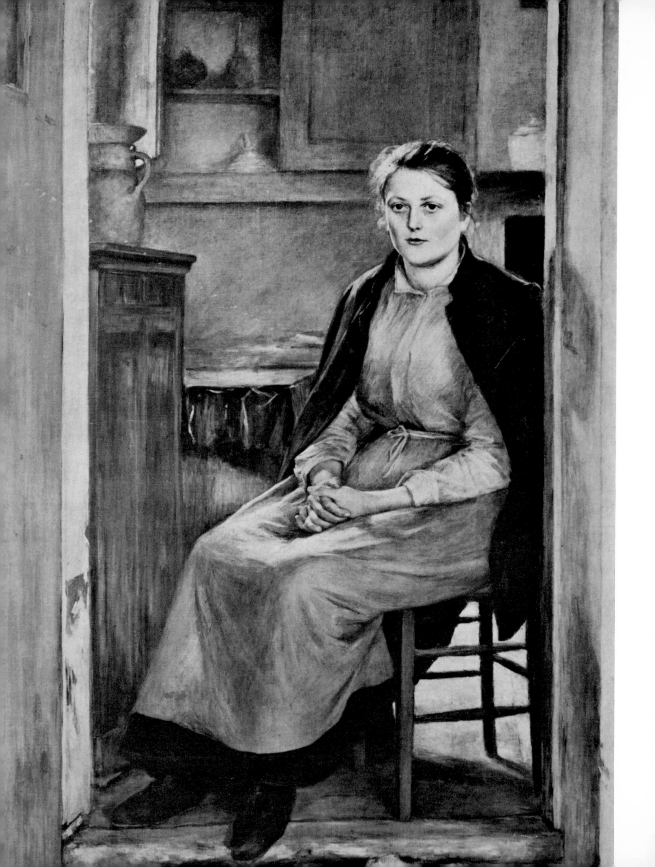

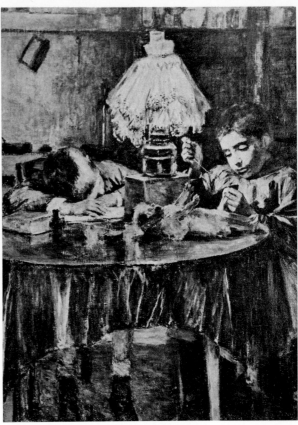

58. *Kuroda Seiki:* Turkey. *Oil. 1891–92. Tokyo National Cultural Properties Research Institute.*

59. *Kuroda Seiki:* Lamp and Two Children. *Oil. 1890–91. Private collection.*

◁ *57. Kuroda Seiki:* Kitchen. *Oil. 1892. Tokyo University of Arts.*

works to the society's exhibitions. The effect these paintings had on the old guard was startling, for they were unaccustomed to the refreshing range of brighter hues. The rivalry that soon grew out of this clash between the old and new came to be called the Purple-Brown controversy for the purple and blue tones used for shading by the *plein-air* painters versus the sober resin tones of the older school. Collin's personal style was nicknamed the *murasaki* (violet) school in contrast to the earlier Meiji *yōga* style, which was called the *yani* (resin) school because of the darkened palette and heavy varnish glazes. The two styles were also given nicknames adapted from traditional pre-Meiji art criticism: "southern school" applied to the more colorful and intuitive style of Kuroda, and "northern school" to the more somber and academic method of

the first generation. The controversy, fanned by journalistic interests, finally reached an acute stage. However, the new wave was clearly in the lead, for Kuroda was invited to join the faculty at the Tokyo Art School in May 1896, and shortly thereafter helped establish the influential White Horse Society. The Purple-Brown controversy had subsided by 1907, but the reverberations of the clash lingered long in *yōga* circles.

The Tokyo Art School, which had originally refused to include *yōga* in its curriculum, could no longer ignore the Western-style movement. With the backing of strong public interest in the newer forms of art, Okakura Tenshin, director of the school, was forced to concede to the pressure of the times and establish a department of Western-style painting,

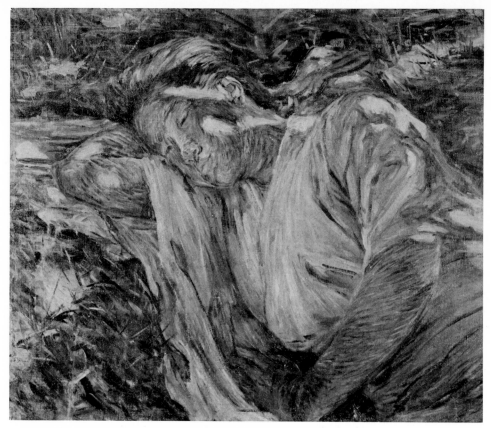

60. *Kuroda Seiki:* Taking a Nap. *Oil. 1894. Tokyo National Cultural Properties Research Institute.*

whose faculty Kuroda and his pupils joined. Kuroda was perhaps the only possible candidate for the position of lecturer, being totally unscathed by the hostilities that had scarred many in *yōga* circles in the 1880s while he was painting in Europe. In the revised faculty organization, Kuroda and Kume were to lecture on Western-style art and art anatomy, assisted by Fujishima, Okada, and Wada. Their courses of instruction were based on those given at the Tenshin Dōjō and provided a most favorable base for the expansion of the *plein-air* school.

Kuroda and his students, committed as they were to a new approach to the problem of reproducing nature on canvas, were not long able to remain as members of the Meiji Art Society, which proved to be a reservoir of conservatism in the teaching of art

theory as well as in human relations. Prompted by the flare-up of the Purple-Brown controversy, the younger group decided to secede from the parent organization to form an association of their own; in June 1896, Kuroda, Kume, Fujishima, Okada, Wada, Yamamoto, Gōda, and Kobayashi, among others, founded the Hakuba-kai (White Horse Society). The society sponsored thirteen exhibitions until its dissolution in 1911 and through them introduced to the public many of what are considered today to be the most representative works of Meiji Western-style painting.

The White Horse Society also contributed substantially to the development of modern art in Japan through educational and research projects. The group sponsored an institute of art, which opened in 1899

61. Kuroda Seiki: The Storyteller. *Oil. 1898.*

at Akasaka Tameike in Tokyo, where students could begin their training in *plein-air* principles. Later the institute moved to the Koishikawa district of Tokyo, where it was renamed the Aoibashi Institute of Art; its members included many of the young *yōga* artists who would take their place among the avant-garde painters of the 1910s and the Taishō era. By the end of the nineteenth century, the *plein-air* artists of the White Horse Society were the leading influence in Western-style art.

As the White Horse Society gained prominence, the more conservative Brown school artists, represented by the Meiji Art Society, lost favor, and the society itself was finally dissolved in 1900. Its former members, including Nakagawa Hachirō, Kanokogi Takeshirō, Mitsutani Kunishirō, Nakamura Fusetsu,

and Oshita Tōjirō, went to Europe, where they continued their studies and where their styles matured considerably. In 1902, these men reorganized themselves into the Pacific Painting Society (see Chapter 5), which like all such groups held periodic exhibitions. A studio was set up by Nakamura and Mitsutani with the sculptors Shinkai Taketarō and Fujii Kōyū to promote their school of painting and sculpture. Despite these efforts, the White Horse Society, led by the strong figure of Kuroda, had a great lead over all other schools and continued to dominate *yōga* circles.

Kuroda Seiki

Kuroda, son of a samurai, was born in Kagoshima at the southern tip of Kyūshū. At the age of four he

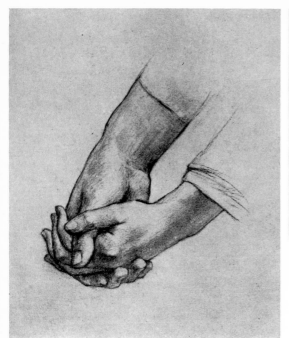
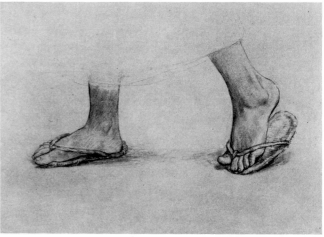

62. (left and above) Kuroda Seiki: Sketches for The Storyteller. *Charcoal. 1896. Tokyo National Cultural Properties Research Institute.*

was adopted by Kuroda Kiyotsuna, an uncle who had been granted the title of viscount in return for his active role in the Meiji Restoration of 1868. By the time he was eleven, Kuroda was already showing a precocious talent in the pencil drawings and water-color studies he was producing under the tutelage of Hosoda Sueji, a former student of Takahashi Yuichi. However, in keeping with his obligations as the adopted son of an influential Meiji-era statesman, he chose to pursue a career in law and went abroad to France intending to enter a program of legal studies. He spent his first year in Paris studying French at a private school prior to his admission to law school in 1887. However, it was during this one-year interim that his professional interest ultimately shifted from juris-prudence to art under the influence of two close

friends living in Paris, Yamamoto Hōsui and Fuji Masazō.

Yamamoto in particular was deeply impressed with the talent he saw expressed in Kuroda's sketches and strongly encouraged him to abandon his plans for a career in law and devote himself entirely to art. The moment of decision followed Kuroda's visit to Raphael Collin's studio as Fuji's interpreter. The paintings he saw there settled any doubts he may have had about becoming a painter. Fuji (1853–1916) had begun his training at the Technical Art School under San Giovanni and Fontanesi and when he was thirty-two had left for France to work under Collin. There he received recognition for *Torn Trousers,* a painting he exhibited at the Salon in 1888. Another of his paintings, *French Landscape* (Plate 54), is a sunny scene par-

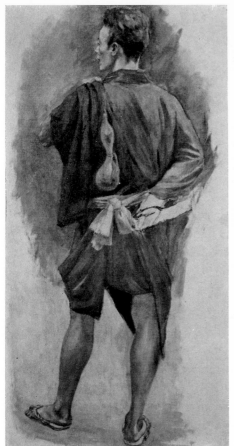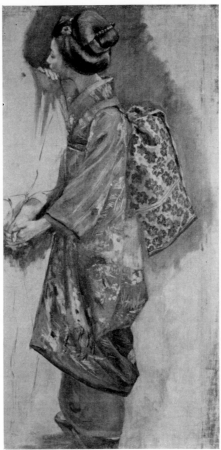

63. Kuroda Seiki: Sketches for The Storyteller. *Oil. 1896. Tokyo National Cultural Properties Research Institute.*

ticularly appealing for the refreshing use of color applied with spontaneous but sensitive brushstrokes. He spent the rest of his life in both France and America and was therefore so far removed from Meiji *yōga* circles that he had no direct relationship to them; but it was through his introduction that Kuroda and other painters met Raphael Collin, and in this indirect way Fuji did influence the direction of Meiji Western-style painting.

When Kuroda wrote to his father of his decision to change his profession, he stated his position in these terms: "I have always assumed until now that only high government officials are worthy of respect; however, a first-rate artist is in no way inferior. The profession of an artist is especially free and easy because it deals with the subject of nature and is a most pleasant way to spend one's life. Other Japanese have become doctors of law in Paris, but none have sought the prizes of the French Salon. If I were to put all of my effort into earning a reputation as a serious artist, it would mean not only a personal honor but a national honor for Japan as well." This letter was written to win his father's approval, but at the same time it clearly set forth Kuroda's own reasoning. Wellborn and ambitious, Kuroda traveled comfortably in the social atmosphere of the Salon, which also attracted the aristocratic French upper class; his choice of Collin's atelier was an equally appropriate move, as the studio at that time was one of the most active in Paris.

Kuroda's rapid progress in his newly elected profession was startling. He worked with prolific energy

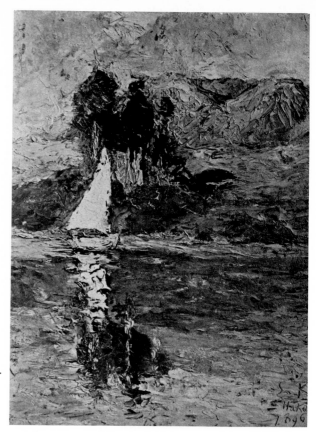

64. *Kuroda Seiki:* Mount Futago. *Oil. 1896. Private collection.*

during the first two years. In June of 1890, he left Paris for Grez-sur-Loing, where his work, including self-portraits and landscape scenes, was striking in both quantity and quality. In 1891 he painted *Reading* (Plate 51), which was accepted by the Société des Artistes Françaises. Also completed during that year were *Woman with a Mandolin* (Plate 55), *Lamp and Two Children* (Plate 59), *Girl of Brittany,* and *Reading in the Suburbs.* Some other paintings worthy of note in this period are *A Country House, Portrait of Kume in His Studio, Self-portrait, Atelier,* and *Landscape in Grez.* The most accomplished of his studies abroad was *Morning Toilette* (Plate 56), painted in 1893 and exhibited at the Société Nationale des Beaux Arts in the same year. It caused quite a controversy when it was exhibited at the Fourth National Industrial Fair. In

Meiji Japan, modesty was the rule, and nude women, much less paintings or sculptures of nudes, were never publicly displayed. Unfortunately, this work was lost in World War II.

Reading (Plate 51), the portrait of a young woman seated by a louvered window absorbed in her book, leaves one with a feeling of freshness in mood and chromatic harmony. Above all, the viewer is aware that it is the artist's open and unassuming sympathy for the scene before him which motivates the movement of his brush. A closer look at the canvas reveals a patient discipline in technical workmanship. The light falling from the window onto the woman's face and clothes is executed in soft, delicate brushstrokes, while the color contrast between the red blouse and the dark blue skirt enlivens the whole texture of the

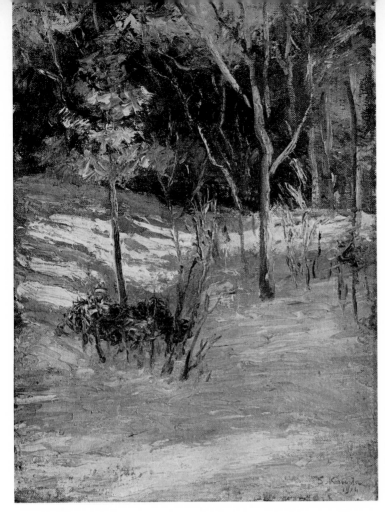

65. *Kuroda Seiki:* Snow in the Woods. *Oil. 1914. Private collection.*

painting. The ingenious composition inclining the woman's head toward the strong diagonal lines of her hands, one holding the book and the other turning the page, creates a spatial tension. As Kuroda progressed in his art, his brushwork became more refined, culminating in his exquisite later works, which go beyond the scope of this study. But few of them can match *Reading* in the balance struck between emotional understanding of the subject and technical expertise.

Kuroda worked equally hard to resolve compositional problems in *Kitchen* (Plate 57), which he painted between 1891 and 1892 and for which he engaged the same model as in *Reading*. Placing his easel in an adjoining room, he studied the effect of light on the woman's figure with utmost care, but fell short

of achieving the expansive harmony attained in the former work. This is far removed from the problem of light in his early paintings, which sometimes borders on affectation. *Lamp and Two Children* (Plate 59) is such a case. A young girl seated behind a table sews a doll's dress by lamplight at the elbow of her dozing brother. The artist was inspired by the heart-warming intimacy of the family scene, heightened all the more by the intricate effects of the artificial light. However, in this case overworked technique only weakens the total impression of the painting.

Kuroda's return to Japan in July of 1893 after ten years abroad sparked a renewed interest in *yōga* painting and launched his *plein-air* movement and the Tenshin Dōjō into the mainstream of Western art in Japan. In the fall of 1893, during a trip to Kyoto, the

ancient capital, Kuroda painted *Maiko* (Plate 67). The young dancer strongly appealed to his artistic sensitivity, for she seemed "so delicate that the slightest touch of a finger might shatter her." To a Japanese eye, the dancer seated by an open window overlooking the Kamo River has a foreign air about her, perhaps because Kuroda's own vision, long alienated from the native scene, had become somewhat Westernized. The contrast between the colorful patterns on the dark kimono and the humid atmosphere hovering over the surface of the water and around the dancer evoke an impression of youth and freshness. Beyond the level of technical accomplishment, the real charm of this canvas is in the artist's strong, free brushwork. Painting as his inspiration dictated, the brushstrokes are unhesitating and firm, resolving this into a solid and brilliant work marking his return to Japanese soil.

Also conceived in Kyoto was the motif for *The Storyteller* (Plate 61), completed in 1898. The idea for the painting was a simple scene viewed on his way to sketch at Seikan-ji temple. He overheard a priest narrating the poignant tale of Emperor Takakura and the Lady Kogō, characters from the *Tale of Heike,* an early thirteenth-century chronicle of the Taira clan. Deeply moved, Kuroda began sketches for a major work that was completed after much deliberation and careful preliminary drawing. The composition centered on the figure of the storytelling priest in the pose of a flute player retelling the story before a small group of attentive spectators. The finished painting is the most characteristic work of the midpoint in Kuroda's career, during which he concentrated on romantic themes and contemporary genre scenes. Unfortunately, the final work has been lost and only the final drawing and a number of partial sketches (Plates 62 and 63) have survived.

Kuroda reached the zenith of his career toward the end of the ninteenth century while lecturing at the Tokyo Art School, organizing the White Horse Society, and producing a series of major paintings. Among these, *By the Lake* (Plate 50), done at a lake in Hakone in 1897, is perhaps one of his best-known works today. The blues used in the woman's summer kimono and the water in the background are differentiated only by subtle gradations of tone. In total effect,

the painting succeeds in bringing together a strong combination of color harmony and classical order, and confirms Kuroda's own oft-pronounced appeal for "refined taste." *Mount Futago* (Plate 64), the location of a famous spa, was also painted in Hakone in 1896. The small but luminous painting carried out with vigorous strokes and warm colors is a surprising contrast to the solid composition and pensive quietness of the former work.

Around 1907 a noticeable change came over Kuroda's paintings, for he no longer produced large-scale works, but rather concentrated on smaller canvases characterized by a mood of ease and serenity (Plate 65). These seem to reflect a more relaxed imagination and are a delight in their simple charm, a crystallization of the security felt by one who had reached a comfortable maturity and public acceptance as an artist.

Kuroda had much to do with the opening of the Bunten, the exhibits sponsored by the Ministry of Education, which were launched in 1907, and no doubt he hoped to see a jury that would be a replica of the Salon he had known in Paris. He served as leading juror of the *yōga* division of the Bunten until it was reorganized in 1918 and renamed the Teiten (Imperial Fine Arts Academy exhibitions).

In 1901, when Kuroda was elected to the Imperial Household Art Academy, he was awarded the title of Imperial Court Artist, which he received with the double honor of being the first Western-style painter to win such recognition. Six years later, he inherited his uncle's title of viscount, and in 1919 was elected to the House of Peers. In 1922 he succeeded Mori Ogai as the second president of the Imperial Fine Arts Academy and died two years later while holding this post.

Kuroda's role in the development of Meiji *yōga* cannot be appreciated in a simple discussion of his stature as a painter, for the scope of his contribution to the field of Western art in Japan also included a basic education of the public concerning the character of modern European art. As an artist he did not attain a uniformity in style, but rather found a kind of balance between the modern and the traditional, a balance characteristic of Japan's modern culture as a whole.

Romanticism and the Plein-Air Painters

The *plein-air* movement led by Kuroda Seiki suc-
ceeded readily because the older schools were unpre-
pared to meet the desire of the rising generation for a
means to give expression to their subjective feelings.
Kuroda upon returning to Japan brought new ideas
of realism in painting as seen through the European
plein-air school, and these principles sparked a trend
toward liberation.

Romanticism in Japan

The strong undercurrent of restlessness among the
younger artists was connected to the wave of roman-
ticism spreading throughout Japanese literary and in-
tellectual circles beginning in the late 1880s and con-
tinuing into the early twentieth century. This was
originally a social movement springing from the
hopes and frustrations of the rising middle class. Some
were exhilarated by the remarkable industrial and
economic strides taken by the nation, while others
were frustrated again and again by the indifference of
the Meiji ruling structure toward individual liberty.
The unsuccessful Popular Rights Movement, which
condemned the despotic nature of the oligarchy and
demanded respect for individual rights and privileges
and the establishment of representative government,
is evidence of the population's opposition to the con-
servative ruling class.

The Romantic movement in Japan went through
several phases in its short history but was further com-
plicated in the 1880s by an infusion of nationalism.
Despite the degree of complexity, the basic philoso-

66. *Aoki Shigeru:* Prince Oanamuchi no Mikoto. *Oil. 1905. Bridgestone Museum of Art, Tokyo.*

phic dilemma of the movement centered on the conflict between the self and the tight social structure that had traditionally bound the Japanese to a rigorous feudalistic family structure: The Romantics, of course, placed individual will, love, and strong passions over the dictates of family and the social hierarchy in the major issues of life.

One of the earliest and most zealous exponents of the Romantic spirit was the poet Kitamura Tōkoku, who had been deeply involved in the abortive political activities of the Popular Rights Movement. Its lack of success touched him deeply, but in his personal struggle against traditional society he continued to sharpen his insights and to hone his poetic sensitivity. The fruits of his struggle were finally channeled into literature in a philosophical autobiography entitled *On the Inner Life.* Torn by the contradiction between the reality of the world and his own idealism, he finally committed suicide in 1894.

The writers for the *Bungakukai,* the literary magazine founded by Kitamura, did not continue to present the irrational abstractions of his thinking, which were entangled in an adamant refusal to accept an impure reality. Instead, they immersed themselves in discussions of the liberation of the senses and the poetic idealization of love. The *Wakana-shū* (1897), the first anthology of the poet-novelist Shimazaki Tōson, who also wrote for the *Bungakukai,* translated Tōkoku's dictum that love "holds the key to the mystery of life" into sensual poetic imagery. Later Romantic literary and poetic groups developed in much the same way as did Shimazaki. *Lyrical Poems,* an anthology jointly published by Sagano Yaomurō, Miyazaki Koshoshi, Kunikida Doppo, Tayama Katai and others, appeared

(overleaf)

67. *Kuroda Seiki:* Maiko. *Oil; ht 80.5, w 65.4 cm. Kuroda traveled to the former capital of Kyoto soon after returning from France* ▷
*to reacquaint himself with traditional Japanese culture. The young girl, a maiko dancer seated beside a window with the Kamo River
flowing behind her, is painted with special attention to the effect of natural light on her face and figure. The air is more fluid, the colors
lighter, the whole effect much more spontaneous than in* Reading *(Plate 51), evidence of the strong influence of the Impressionists on
Kuroda's style. 1893. Tokyo National Museum.*

68. *Aoki Shigeru:* Yomotsu Hirasaka. *Watercolor; ht 48, w 33.3 cm. This work won instant fame for Aoki after it was awarded a* ▷
prize at the eighth White Horse Society exhibition in 1903. The subject is taken from the chapter on the Age of the Gods in the Nihon
Shoki, *the eighth-century chronicle of Japanese history. Prince Izanagi has come to visit his deceased wife Izanami in Yomotsu, the
world of the dead. Shocked by its ugliness, he flees, pursued by some of the inhabitants. The depth and mystery of Yomotsu is evoked
by rich pastels and unbridled brushwork, and particularly by the predominantly purple-blue palette. Aoki, whose works are most repre-
sentative of the Romantic influence in Meiji painting, often drew on legendary and medieval themes for his motifs. 1903. Tokyo Uni-
versity of Arts.*

in the same year as *Wakana-shū,* and in 1900 Yosano Tekkan published a magazine called *Myōjō* (Venus), which was subtitled "a magazine devoted to literature and art." Akiko, Yosano's wife, published her anthology of *tanka* poems in a volume entitled *Midaregami* in the following year.

Romanticism never became a clearly defined movement among art circles, although certain ideas were absorbed into current styles and although some of the younger artists who flocked to the *plein-air* school were the spiritual cousins of the literary Romantics. If any one group embodied the spirit of the Romantics, it was the White Horse Society founded by Kuroda Seiki, for his teachings gave young painters the means to express their inner feelings.

There was, of course, no direct parallel between the teachings of Kuroda and the original European concept of *plein-air,* for it was the personal style of Raphael Collin that Kuroda had transplanted onto Japanese soil. Nevertheless, even in this peculiar form, the *plein-air* movement helped the members of the White Horse Society to break with the past and give form to their emotions through the use of a totally fresh chromatic scale. It was the creative effort of these artists that accelerated the changes in *yōga* style around the turn of the century and thus contributed to the maturing of a modern Western art style in Japan.

Among the works shown at the successful White Horse Society exhibitions, which were held annually from 1896 until its tenth anniversary in 1905, are many that can be considered the masterpieces of the major artists who were active in the group. These include Wada Eisaku's *Evening at the Ferry Crossing* (Plate 97),

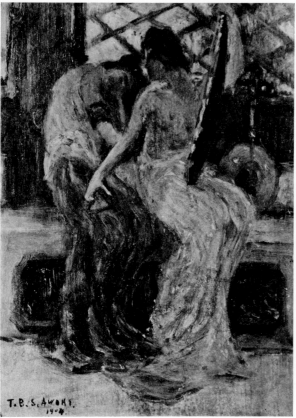

69. Aoki Shigeru: Pleasure. *Oil. 1904. Ohara Art Museum, Okayama Prefecture.*

70. Aoki Shigeru: Prince Yamato Takeru no Mikoto. *Oil. 1906. Tokyo National Museum.*

Shirataki Ikunosuke's *Music Lesson* (Plate 98), Kuroda Seiki's *The Storyteller* (Plate 61), Kobayashi Mango's *Strolling Musicians* (Plate 96), Akamatsu Rinsaku's *Night Train* (Plate 101), Fujishima Takeji's *Memory of the Tempyō Era* (Plate 87), Okada Saburōsuke's *Reading* (Plate 85), Aoki Shigeru's *Yomotsu Hirasaka* (Plate 68), Fujishima Takeji's *Butterflies* (Plate 90), and Aoki Shigeru's *Harvest of the Sea* (Plate 72). Of all these artists, the two most intimately linked to Japanese romanticism through the highly subjective styles they created are Aoki Shigeru and Fujishima Takeji.

Aoki Shigeru

Filled with youthful dreams of one day conquering the world of art, Aoki Shigeru (1882–1911) set out from his native Kyūshū for Tokyo in 1899 with little more than a volume of Shimazaki's *Wakana-shū,* the bible of Japanese romanticism. He took no interest in his inherited role as a retainer for the Arima clan, but chose instead to focus on the arts and literature. While yet in junior high school, he contributed articles to school publications, studied Western-style painting, and gradually awakened to a world of self-expression. His tradition-oriented father did not share his son's passion for the arts, and the strained atmosphere between father and son was a sharp blow to young Aoki. There are those who attribute his notoriously cantankerous behavior in later years to this early disappointment. In the end, however, his father did relent and permit Aoki to leave for Tokyo to pursue his interest in art.

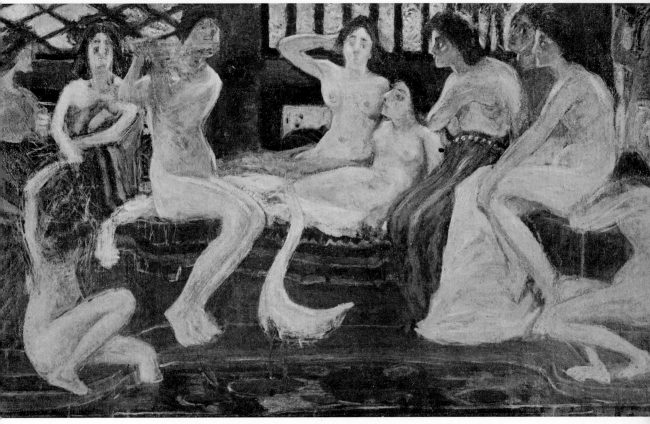

71. *Aoki Shigeru:* Tempyō Era. *Oil. 1904. Bridgestone Museum of Art, Tokyo.*

Once there, Aoki was briefly enrolled as a student in Koyama's Fudō-sha until the time he was accepted as a special student at the Tokyo Art School in 1900. The air was alive with the heady philosophy of the Romantic movement that was sweeping the arts and contemporary thought, and Aoki, at the threshold of his career, was most responsive to its ideals. The stories told of him in those days often concern his eccentric behavior as a student—his reciting free verse spontaneously before his colleagues, or his making a rapid exit from a classroom to avoid an encounter with Kuroda, whom he deeply respected, but who represented a type of restriction imposed on his art which he resented. On the other hand, he was a talented, devoted student who made frequent trips to the public library to educate himself in religion, philoso-

phy, history, and mythology. To judge by his paintings, this reading nourished his fertile imagination into expressing itself in fanciful imagery and brilliant colors.

His earliest extant works are the product of a sketching trip made in 1902 with several friends to Mount Myōgi in central Japan. Although these are all rough sketches drawn in pencil and light colors, the flow of his pliable, soft lines projects beyond the physical shape of the landscapes to catch the mood as well. Aoki's superb gift for drawing enabled him to transfer to canvas a deep poetic sensibility closely in tune with nature. In 1903, he submitted to the eighth exhibition of the White Horse Society *Yomotsu Hirasaka* (Izanagi Fleeing the Underworld), illustrated in Plate 68, *Jaimini* (a portrait of an ancient Indian philosopher),

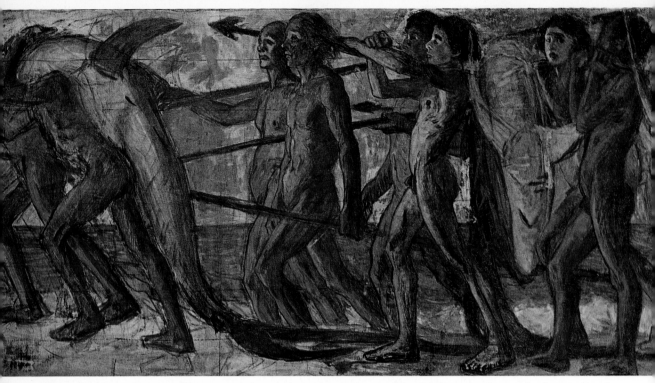

72. *Aoki Shigeru:* Harvest of the Sea. Oil; ht 66.6, w 178 cm. *Fishermen file across the canvas bearing the day's catch on their shoulders. A gold-colored sky, deep blue sea, and breaking waves on the shore provided an uncluttered background against which a rhythmic cadence vibrates from the strong horizontal movement. Judging from the unpainted areas of the canvas, the painting, which is classified as an Important Cultural Property, is unfinished. The figures of the men and the muscular movement are drawn with dashes of heavy black lines, rather than rounded through light and shade, and the underpainting shows that Aoki changed his mind about the final position of the leading figures. The young figure that faces inward is said to be Aoki himself.* Harvest of the Sea *reflects Aoki's youthful vitality and the atmosphere of Romantic philosophy permeating the arts, as well as a vision that goes well beyond a mere analytical rendering of the subject. This moving work draws the viewer into the individual world of the artist. 1904. Bridgestone Museum of Art, Tokyo.*

and other mythological compositions thoroughly representative of his style that reflect as well the highly pervasive atmosphere of romanticism.

Forced by poverty to improvise on materials, Aoki had used watercolor and colored pencils in place of oils to produce the fresh, haunting coloring of these canvases, which are remarkable expressions of a youthful imagination. Kambara Ariake, the poet and contemporary of Aoki, was deeply moved by what he saw. "My heart jumped when I saw on those canvases forms that were barely intelligible. The powerful magic of his paintings had an almost frightening effect on me." The unusual quality of Aoki's work did not pass unnoticed; he was given the highest White Horse Society award for this underworld scene.

The years from 1902 to 1904 were marked by the production of a number of imaginatively fanciful works, among them *Pleasure* (Plate 69) and *Tempyō Era* (Plate 71), heralds of the best period of his brief life. The climax came with *Harvest of the Sea* (Plate 72), which was shown at the ninth White Horse Society exhibition. Immediately following his graduation from the Tokyo Art School in July 1904, Aoki had spent a relaxed and contented summer at the seaside village of Mera at the tip of the Bōsō Peninsula, surrounded by friends such as Morita Tsunetomo, Sakamoto Hanjirō, and Fukuda Tane, who was to be his mistress in later years. It was in this atmosphere of personal happiness and fulfillment that *Harvest of the Sea* was nurtured.

Against a background of golden horizon, blue sea, and the white spray of breaking waves, a group of

73. *Aoki Shigeru:* Fish-scale Palace in the Sea. *Oil; ht 181.5, w 70 cm. This painting, as well as* Yomotsu Hirasaka *(Plate 68), is based on a legend from the* Nihon Shoki. *Yama Sachihiko, a hunter, and Umi Sachihiko, a fisherman, are brothers. One day, Yama Sachihiko takes his brother's fishing gear to go fishing but soon loses the fishhook. He descends into the sea to find it, and there he meets and marries Toyotama-hime, Princess of Rich Jewels. Here, Yama Sachihiko looks down from the branches of a sacred tree at Toyotama-hime (on the left) and her servant. The startled princess later returns to her father to say, "I have seen a man on the tree by the well. His countenance is very beautiful and his form comely. He is surely no ordinary person." The legendary love scene is described in soft, sensuous pastels, and the mood of tranquillity and elegance that fills the canvas is characteristic of Aoki's maturing style. 1907. Bridgestone Museum of Art, Tokyo.*

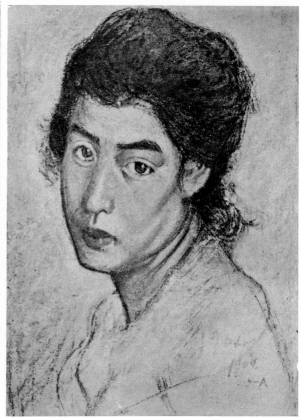

74. *Aoki Shigeru:* Self-portrait. *Oil. 1904. Tokyo University of Arts.*

75. *Aoki Shigeru:* Woman's Face. *Oil. 1904. Private collection.*

fishermen marches across the canvas, hauling the day's catch on their shoulders. The powerful rhythmic cadence that resounds from the canvas creates a compelling grandeur and solemnity that attracts and holds the viewer. Aoki's friend Kambara translated his personal encounter with the painting into poetry:

See, the deep harmony of blues and golds—
High spirits flowing like the tide
Indestructible footsteps reaching toward heaven,
Echoing like an unending symphony.

Look at you, closely resembling a race of gods,
High waves beating vigorously along the beach,
Harpoons in hand, sharp and pointed,
Fishermen stride on.

But *Harvest of the Sea* is not just a symbol of the artist's youth, or an expression of his own exuberance: It is also among the most notable examples of modern Western-style painting in its Romantic phase, for it is far more than the analytical rendering of muscular movement in naked bodies and the tightly knit organization within an oblong composition.

There is yet another dimension to this work, for the young figure, which faces inward, is said to be Aoki himself. He repeated this form in other works as well, so that many of his paintings could be interpreted as self-portraits. In one that is clearly so labeled, *Self-portrait* (Plate 74), the tightly controlled brushstrokes with which the artist has laboriously re-created his own image cannot conceal an indomitable personality. Representative of several of his self-portraits, the work

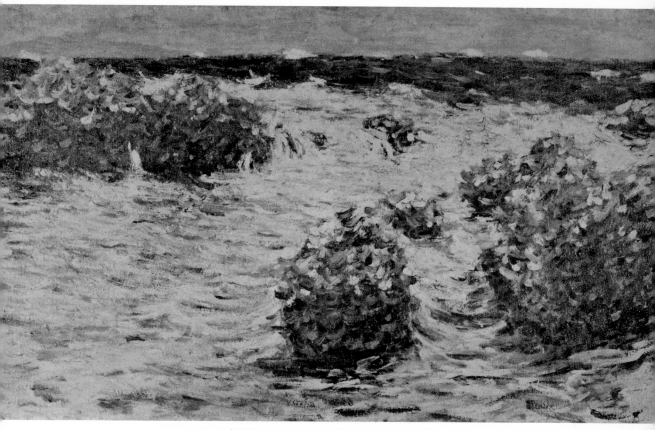

76. *Aoki Shigeru:* Seascape. Oil. *1904. Private collection.*

contains a feeling of pent-up emotion that is noticeably absent in his mythological works. The inscription "Aoki in his days at the Tokyo Art School" is in commemoration of his own graduation.

The work that marks the end of both Aoki's youthful period and the prime of Meiji *yōga* is *Fish-scale Palace in the Sea* (Plate 73), a painting on which he had exerted tremendous effort. It takes its theme from an ancient Japanese myth recorded in the *Nihon Shoki* (Chronicles of Japan) of the brothers Umi Sachihiko and Yama Sachihiko, a fisherman and a hunter. In Aoki's version, Yama Sachihiko is sitting on the branch of a sacred Judas tree, looking down on Toyotamahime, Princess of Rich Jewels, and her maidservant. The scene is executed as a strong vertical composition of rich shades of greens and blues used to suggest the

depth of the mythological underwater setting. The work is one of his major efforts, one in which the pulse and energy of *Harvest of the Sea* is overshadowed by a dreamlike, reserved and understated mood.

Even before the completion of this painting, which to his disappointment received only a minor award at the Tokyo Industrial Exposition, the waning of the Romantic movement had changed the climate of acceptance for his work. Men of more conservative bent had begun to dominate the major art circles, and in 1906, *Woman's Face* (Plate 75), the portrait of his mistress Tane, was rejected by the White Horse Society for an exhibition commemorating the victory in the Russo-Japanese War. Aoki's heroic efforts toward self-expression had, in effect, been sacrificed in a power struggle among the jurors, who were themselves be-

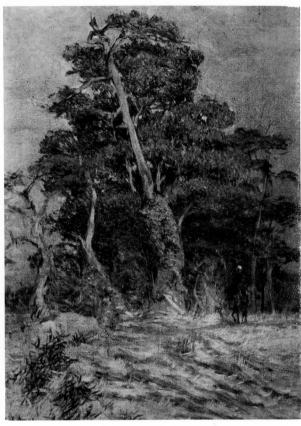

77. Aoki Shigeru: Sketch for Fish-scale Palace in the Sea. *Oil. 1907. Private collection.*

78. Aoki Shigeru: Chikugo Landscape. *Oil. 1908. Tokyo National Museum.*

ginning to lean toward a new conservatism that was reflected in the mediocre paintings they selected for entry.

There were also personal problems. The poverty of his parents' home became a burden on him, the eldest son. Just as the Ministry of Education's new exhibitions, for which he held great hopes, were opened, his father died, and the disillusioned Aoki returned home to Kyūshū. In a desperate inner turmoil, he abandoned his family in poverty and turned to a life of vagrancy. Three years later, at the age of twenty-nine, he died of tuberculosis.

Fujishima Takeji

Fujishima's (1867–1943) early works as a member of the White Horse Society seem to be faithful imitations of Kuroda both in theme and style. Yet, underneath the level of similarities is Fujishima's strong personal style, expressed in a taste for ancient Eastern thought and traditional Japanese art. As a child he had been instructed in the Taoist philosophy of Lao-tzu and Chuang-tzu, and while still young he had begun studying painting under a Shijō school artist. Later he went to Tokyo to continue studying Japanese-style painting, this time with Kawabata Gyokushō. His desire to study Western-style painting led him to enroll as a pupil of Soyama Yukihiko in 1890, and then to study under Nakamaru Seijūrō, Matsuoka Hisashi, and Yamamoto Hōsui. Fujishima's work from this period includes *Pitiful*, the picture of a girl chasing a butterfly with a cherry branch, and *Cherry Blossom Viewing*,

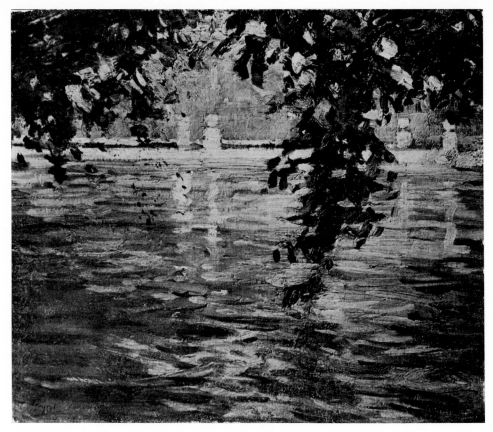

79. *Fujishima Takeji:* Villa d'Este Pond. *Oil. 1908–09. Tokyo University of Arts.*

an outing of court ladies in early spring. Shown respectively at the third and fifth exhibitions of the Meiji Art Society, both paintings reflect the characteristic careful drawing technique of the Shijō school and the manneristic composition of Yamamoto.

Kuroda Seiki and Fujishima both hailed from Kagoshima, and the two painters came to know each other through correspondence during Kuroda's sojourn in Paris. Kuroda made arrangements for Fujishima to see and study the European works that were arriving at his home in Japan. Kuroda was impressed by the talent of the younger student, and when he returned and joined the department of Western-style painting at the Tokyo Art School, he called Fujishima, who was teaching art at a prefectural high school, to become his associate. It was during his association with the

White Horse Society that Fujishima's style changed perceptibly from a faithful imitation of Kuroda to an independent personal manner. *Memory of the Tempyō Era* and *Butterflies,* for example, are decorative canvases tinged with a Romantic flavor and a thorough absorption of the *plein-air* technique.

Memory of the Tempyō Era (Plate 87), a long vertical canvas, takes as its theme a young woman in classic costume holding a harp against a decorative background of traditional gold leaf. The composition skillfully combines the horizontal line of the wall, the abruptly vertical line of the paulownia tree, and the sinuous curves of the woman and her harp. The color harmony, despite the predominance of gold, clearly indicates an effort to create a new decorative style. From this ingeniously contrived composition emerged

80. *Fujishima Takeji:* Ciociara. *Oil. 1909. Bridgestone Museum of Art, Tokyo.*

81. *Fujishima Takeji:* Portrait of an Italian Lady. *Oil. 1908–09. Tokyo University of Arts.*

82. *Fujishima Takeji:* Happy Morning. *Oil. 1909. Private collection.* ▷

an enticingly sensual mood that moved the Romantic poet Kambara Ariake to dedicate a sonnet beginning with the lines, "What dost thou search, a thousand years or dust, fair maiden?"

Butterflies (Plate 90) is another of Fujishima's decorative canvases, on which a young girl kisses a flower against a tapestrylike background of butterflies and flowers all in a field of cobalt blue. The liveliness of the canvas and the Romantic overtones are evoked by the contrasting tones of the yellow blouse, the solid blue background, and the multicolored hues of the butterflies and flowers. The works of well-known Western-style artists, including those of Fujishima, were often used for the cover and the illustrations of the magazine *Myōjō*. *Butterflies* in particular makes Fujishima a spiritual brother to the poets rallying

around the magazine, men who were joined in a search for the expression of sensual beauty.

Fujishima's long career was marked by turns of success and disappointment. After *Tempyō Era* and *Butterflies* came a five-year stay in France and Italy from 1905 to 1910, during which he produced some of the most original works shown at the thirteenth White Horse Society exhibition. Fujishima had departed for Europe with a letter of introduction to Raphael Collin from Kuroda, but chose instead to study under Fernand Cormon, first at the Institut Grande-Chaumière and then at the National Academy of Art, where he was immersed in the principles and theory of the academic style. But he was also quite conscious of the new currents in France, particularly the work of the Expressionist Fauves Matisse and

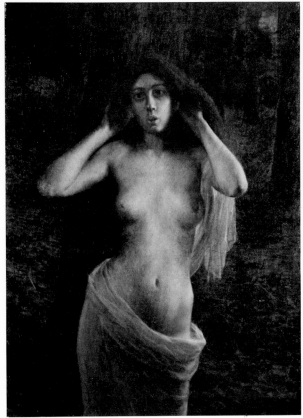

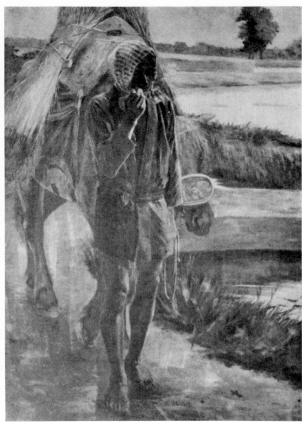

83. Wada Eisaku: Echo. Oil. *1902. Private collection.*

84. Kobayashi Mango: Farmer's Return. Oil. *1898. Tokyo University of Arts.*

Vlaminck, who had formed the Salon d'Automne in opposition to the established academy salons. Another spur to his creative efforts came from the Cézanne Memorial Exhibition, which opened in 1907, the year after Cézanne's death, and from the new art pouring from the post-Impressionist groups.

In 1909 Fujishima moved to Italy to work with Carolus-Duran, president of the French Academy in Rome and a well-known portrait artist. To the techniques and ideas the artist had absorbed in France now were added those of the ancient culture of Italy, specifically that of the art of the Renaissance. The effects of his interest and his research were reflected in the best of his paintings, which combined the idiosyncrasies of his own taste with the European principles he had learned. Representative of this moment in his

career is *Villa d'Este Pond* (Plate 79), done between 1908 and 1909, which along with *Pompeii* was the fruit of his occasional excursions to other parts of Italy. The pond in *Villa d'Este* is bathed in a fresh, harmonious light, and there is a feeling of serenity in the quietness of the receding plane. An earlier landscape, *Yacht* (Plate 95), painted in 1908 in Switzerland while he was en route to Rome, expresses the charm and the illusion of expansiveness often found in his painting. It is a simple scene of a sailboat on Lake Léman painted in bright, fresh colors with quick, emphatic brushwork.

Fujishima's studies in portraiture in Rome yielded several canvases. During his last year there he painted *Black Fan* (Plate 91), a composition based on the vibrant contrast between the black of the fan and the

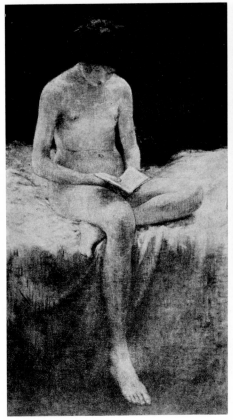

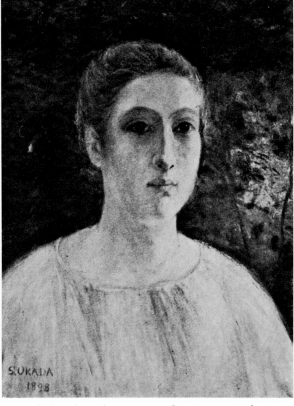

85. *Okada Saburōsuke:* Reading. *Oil. 1901.*
Private collection.

86. *Okada Saburōsuke:* Portrait of a Woman. *Oil. 1898.*
Tokyo University of Arts.

white of the veil covering the woman's head. In addition to the dramatic use of color, the work derives both dignity and vitality from his facile brushwork. *Ciociara* (Plate 80) and *Happy Morning* (Plate 82) were among other works painted in Italy in the same year.

Upon his return to Japan in 1910, he joined the group of artists centered around the Bunten, but found to his disappointment that his innovations were generally not understood. His ideas did reach one small group, however, that of the young radical artists who had formed a splinter society called the Nika-kai as a challenge to the conservative jurors of the Bunten exhibits. But although the Nika-kai named Fujishima their patron, he was never an active member of the group and in fact continued his participation in the Bunten organization. He also taught at the

Tokyo Art School, and it was through this avenue that he exercised a lasting influence on the new generation of Western-style painters of the Taishō and Shōwa eras.

Other White Horse Society Members

Under Kuroda Seiki, the White Horse Society became synonymous with the *plein-air* group. The work of all its members reflected a common preoccupation with the problem of translating natural light into oils on canvas, and many of the paintings reveal social attitudes and concern themselves with humanistic themes on the life of the common man. The exhibits of the society, like all exhibits during this period, set the artistic trends of the time. They were also a forum

for launching the careers of minor painters who would
otherwise have gone unrecognized.

Wada Eisaku (1874–1959), born in Kagoshima, be-
gan his training under Soyama Yukihiko and Harada
Naojirō and later moved to the Tenshin Dōjō to work
under Kuroda. After three years, Kuroda invited him
to serve as his associate on the faculty of the depart-
ment of Western-style painting at the Tokyo Art
School, but Wada, preferring to continue as a student
for one more year, refused the offer. The soft colors
of a work from this period, *Evening at the Ferry Cross-
ing* (Plate 97), show Wada's consuming interest in
the problem of translating sunlight into oil paints. It
was originally painted to fulfill a graduation require-
ment in 1897, but was also submitted to the second
White Horse Society exhibition.

The subject of the painting is a family of farmers
waiting for the Tama River ferry at the Yaguchi cross-
ing in the suburbs of Tokyo. A broad river divides
the canvas into two major planes—the far shore of
woods and hills, and the near bank with a group of
people casually cast in various positions. What strikes
the viewer about the painting is the skillful manipula-
tion of evening light enveloping the scene and its in-
tricate effects on the figures and on the landscape. The
tones of the clouds and river are reminiscent of the
plein-air palette. The setting sun, itself invisible, is felt
in the illumination of the family, the delicate shading
of the figures and surrounding landscape, and the
reflection from the surface of the river.

In 1900, Wada went to study under Raphael Collin
in Paris. *Echo* (Plate 83), a rather mysterious rendering

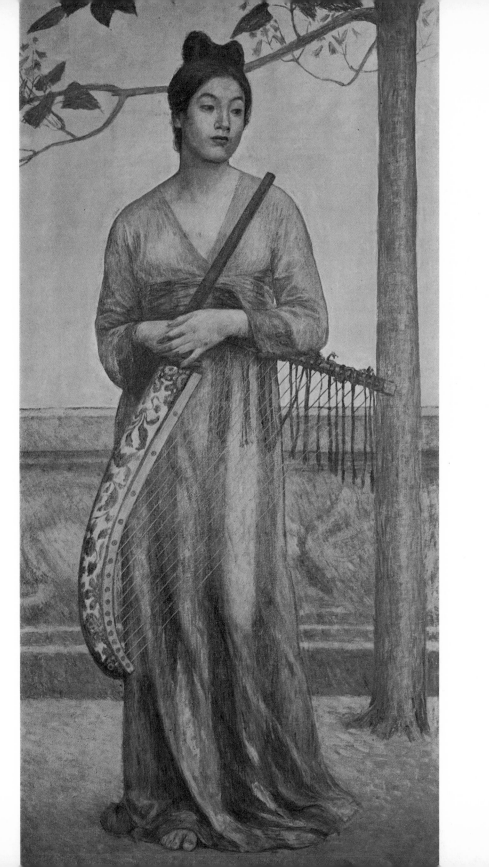

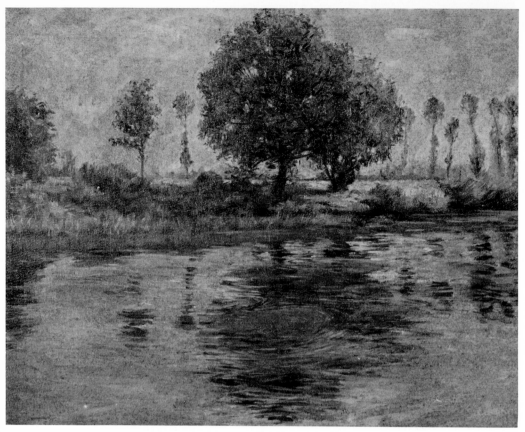

88. Okada Saburōsuke: Upper Seine. *Oil. 1899. Tokyo University of Arts.*

of a semi-nude woman listening to the sounds of the woods, was painted while in Europe and evokes a Romantic sensuousness through gentle shading of the figure and barely visible handling of the brush. Wada, whose work gives evidence of his debt to Kuroda, was later appointed professor at the Tokyo Art School, and remained an influential figure in Western-style painting throughout the Taishō and Shōwa eras.

Music Lesson (Plate 98) is a typical scene of a traditional samisen teacher and her young pupils. Although the setting is indoors, the artist is nonetheless preoccupied with the path of natural light pouring in from the wide window. That the actual shading of the figures and the distribution of light over the various objects do not necessarily coincide with the source of light is a defect, but the skill with which Shirataki

Ikunosuke, the painter, gives character to faces and movement to gestures unifies the various elements of the room into a well-knit composition.

Shirataki (1873–1960), originally from Hyōgo Prefecture, studied first under Yamamoto Hōsui and later under Kuroda at the Tenshin Dōjō. By the time he entered the Tokyo Art School in its opening year, his artistic talent had already been recognized. Kuroda's influence is apparent in the way Shirataki concerned himself with the movement of natural light in his paintings. He also studied abroad in both Europe and America from 1904 until 1910, and exhibited frequently at the Bunten and Teiten, which continued to set the pace in art circles.

Kobayashi Mango (1870–1947), the painter of the poignant *Strolling Musicians* (Plate 96), studied first

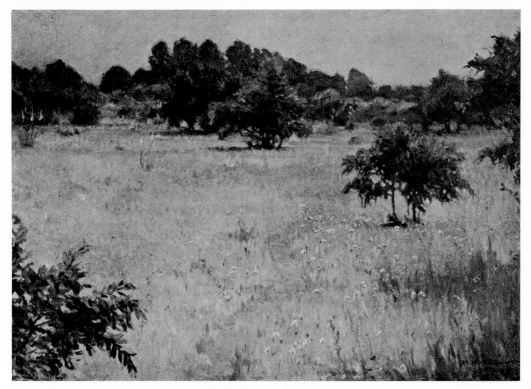

89. Nakagawa Hachirō: End of September. *Oil. 1910. National Museum of Modern Art, Tokyo.*

under Harada Naojirō and Andō Chūtarō, and was later a special student at the Tokyo Art School through his connection with the Tenshin Dōjō. This work, first exhibited at the fifth White Horse Society exhibition, portrays two musicians in an eerie glow of evening light. A woman with a straw hat accompanies a singer on her samisen as they pass from door to door, and a passing child casts the two a backward glance. The twilight lingering in the sky embraces both the figures and their surroundings in its cheerless air, intensifying the feeling of pathos. The painter's social attitudes are not revealed here, but his human sympathy for the subject, one of the characteristics of the early *plein-air* artists, is clearly conveyed.

Night Train (Plate 101) effectively re-creates the somber atmosphere aboard a third-class train. This is a major painting by Akamatsu Rinsaku (1878–1953), who studied at the Tokyo Art School for a short while. Technically the artist's primary concern is with the effect of different kinds of light from various sources on a given focus, and to suit his purpose, he has included the dim glow of light from the ceiling fixture, the rays of morning light visible through the train window, and the blaze of a match lighting the old man's pipe. The overall effect of the painting is less in such technical experimentation than in the re-creation of the stagnant air enveloping the passengers. Besides Akamatsu's particular contribution as a painter to Meiji *yōga,* he also played a major role in forwarding art education, founding the Akamatsu Western Painting Institute in Osaka in 1908 and serving as principal of Kansai Women's School of Art.

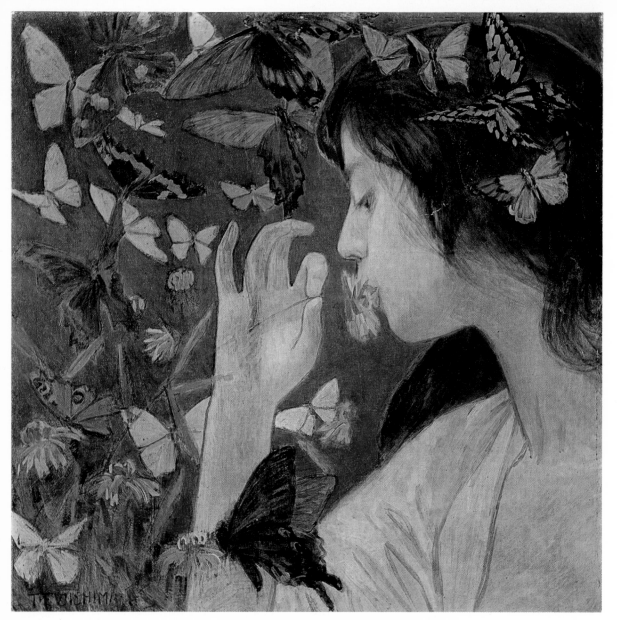

90. *Fujishima Takeji:* Butterflies. *Oil; ht 43.5, w 43.5 cm. The profile of a young girl kissing a flower against a brilliant cobalt background of butterflies and flowers is typical of Fujishima's tapestrylike style. In* Butterflies, *he has captured the Romantic spirit itself on canvas. As in* Memory of the Tempyō Era *(Plate 87), in this work Fujishima has gone beyond the plein-air style that dominated his early paintings to create his own unique expression through delicacy of line and brushstroke, imaginative composition, and brilliant color. 1904. Private collection.*

91. *Fujishima Takeji:* Black Fan. *Oil; ht 63, w 41 cm. Fujishima studied portraiture in Rome, and this particular work stands out for the dramatic balance between the white tones of the veil and blouse and the black fan. This portrait and* Yacht *(Plate 95) were both painted abroad and reflect a new range in subject matter and in spatial depth. The use of shading gives the model's face an illusion of volume in contrast with the pure fantasy and tapestrylike effect in* Butterflies *(Plate 90). 1909. Bridgestone Museum of Art, Tokyo.*

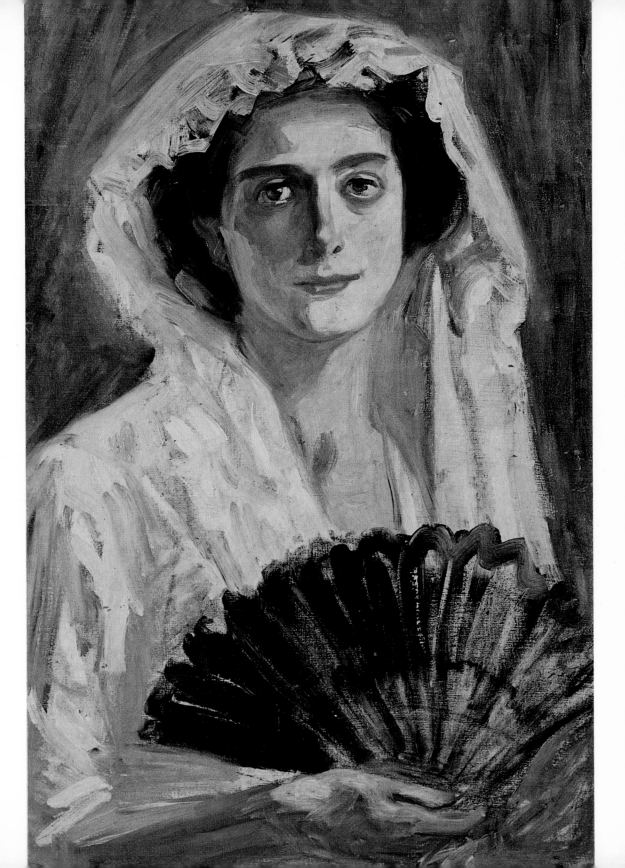

92. Mitsutani Kunishirō: Slight Illness. *Oil. 1907. Private collection.*

93. Kanokogi Takeshirō: Portrait of Master Laurens. *Oil. 1906. Private collection.*

94. Kanokogi Takeshirō: European Lady. *Kyoto Crafts and Textile College.* ▷

Okada Saburōsuke (1896–1939) was born in Saga, the same prefecture as Kume Keiichirō, and through this connection came directly into Kuroda's circle to study the *plein-air* technique. After three years of study in France under Raphael Collin, Okada was appointed professor at the Tokyo Art School and later became a well-known figure among artists participating in the Bunten. His style is characterized by grace in subject matter and soft harmonious color applied gently to rounded forms. All his paintings push the style of the *plein-air* artists and Impressionists to a new level of refinement and sensitivity that is visible in his landscapes as well as his portraits. The same lucid strokes give a structural grace to the young figure of a nude in *Reading* (Plate 85), to the portrait of the Genroku

lady (Plate 103), and equally to the structure of the landscape in Plate 88. His portraits stand out in a kind of painted relief against dark monochrome backgrounds, and the tree is also given a solitary position in nature. It is considered and painted as an object, not as an eternal part of nature, and blended as part of the atmosphere and light surrounding it.

The Pacific Painting Society

The Pacific Painting Society (Taiheiyō Gakai) was the direct descendant of the old Meiji Art Society, which had been eclipsed by the White Horse Society movement. In 1899 two of its younger members, Yoshida Hiroshi and Nakagawa Hachirō, began their

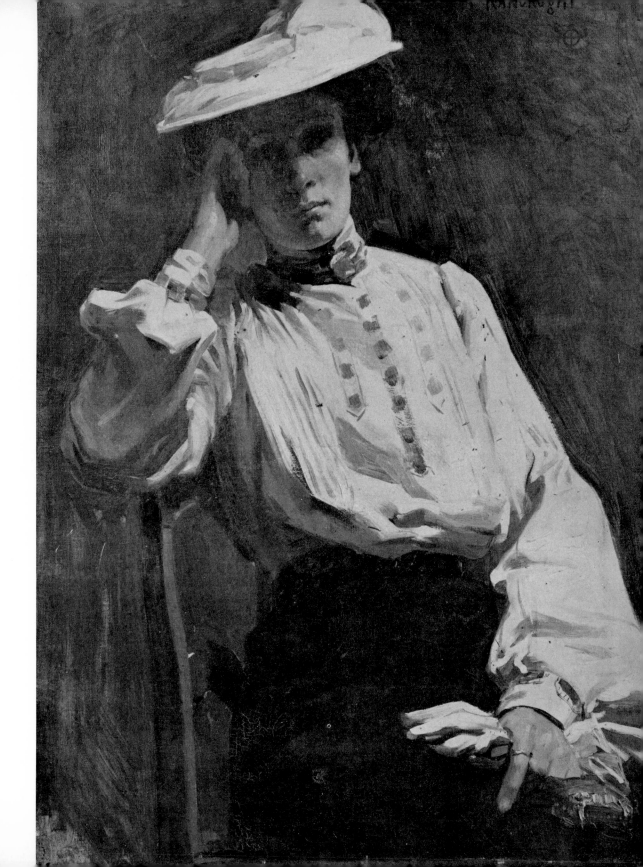

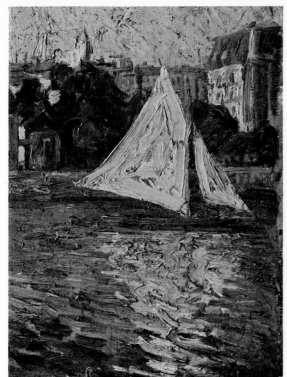 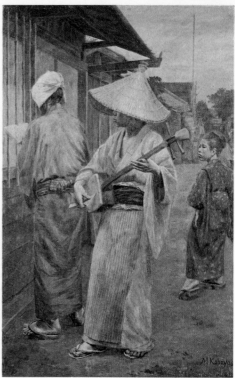

95. *(left)* Fujishima Takeji: Yacht. Oil; *ht 33, w 23.5 cm.* Fujishima spent four years studying in Europe, both in France and in Italy. On his way from Paris to Rome, he passed Lake Léman in Switzerland, where this canvas was painted. The white sail of the boat reflected in the dark blue water and the colors and brushwork are refreshingly free in style, the fruit of his work abroad and his effort to refine his technique. Because of the rough and powerful brushstrokes, Yacht gives an impression of size and strength out of proportion to the smallness of the canvas on which it was done. It is also in marked contrast to Butterflies *(Plate 90)* and Memory of the Tempyō Era *(Plate 87),* both of which were done before he went abroad. *1908. Tokyo University of Arts.*

96. *(right)* Kobayashi Mango: Strolling Musicians. Oil; *ht 157.5, w 108.1 cm.* Two indigent musicians are seen entertaining in the streets, observed by the child in the background. The eerie brightness of the sky casts soft shadows over the figures and dramatizes the pathos in the scene. One characteristic of plein-air painters was the treatment of everyday subject matter with sensitive understanding. Here, as in Akamatsu's Night Train *(Plate 101),* the artist's own human feelings infuse the painting with a sort of tender pity. Strolling Musicians was first shown at the fifth White Horse Society exhibition. *1900. Tokyo National Museum.*

97. *(above)* Wada Eisaku: Evening at the Ferry Crossing. Oil; *ht 126, w 190 cm.* At the close of day, a farmer's ▷ family waits for the ferry on a river bank. The light from the setting sun skims over the surface of the water, tints the layers of clouds, and enfolds the figures in twilight hues. The painting is representative of the techniques of the plein-air school taught by Kuroda Seiki, though the use of blues and lavenders for the shading gives a still, tableaulike effect that contrasts with the vibrating sense of atmosphere in Maiko *(Plate 67).* This was Wada's final assignment before graduating from the department of Western-style painting at the Tokyo Art School. *1897. Tokyo University of Arts.*

98. Shirataki Ikunosuke: Music Lesson. Oil; *ht 137, w 197 cm.* The scene is that of a typical music lesson in ▷ Tokyo of the Meiji era. The natural light filling the room illumines the face of the teacher and the figures of her students. The strength of the work is diminished by the uncertain source of light and the inconsistent direction of the shadows cast over the figures, but it is nevertheless a valid attempt to explore the effects of natural light in the medium of oils and identifies Shirataki as a member of the White Horse Society. *1897. Tokyo University of Arts.*

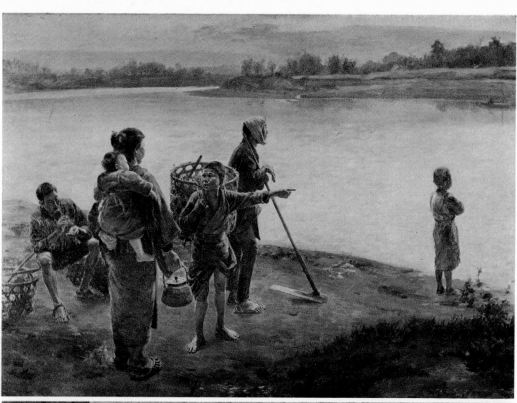

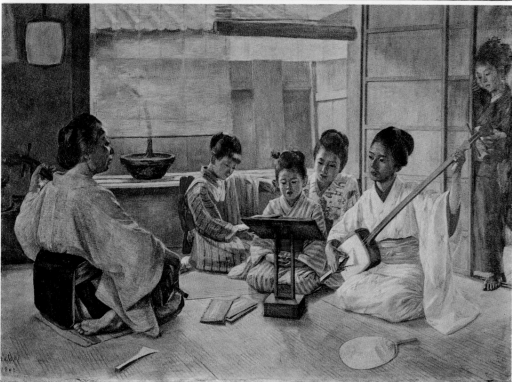

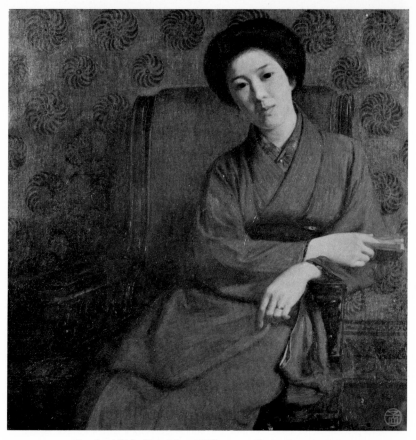

99. Kanokogi Takeshirō: New Wife. 1909. Kyoto City Art Museum.

studies abroad by traveling first to the United States to sell their works and then to Europe with their earnings. They were followed by Kanokogi Takeshirō, Mitsutani Kunishirō, Maruyama Banka, Nakamura Fusetsu, and Oshita Tōjirō, all of whom shared a frustration at the dominance of the White Horse Society and its techniques. These were young men in search of something new.

In Paris, Kanokogi, Mitsutani, and Nakamura were accepted at the Académie Julian, where they studied under Jean-Paul Laurens (1838–1921), whose painting *Lettel and His Apprentice* was shown at the fourth Pacific Painting Society exhibition. The shift to Laurens was a clear indication of the desire of these young painters to break away from the eclectic style of Collin

advocated by Kuroda Seiki and the White Horse group. Abandoning Collin's emphasis on the palette of the Impressionist school, Kanokogi and the others focused on a disciplined sense of form rendered according to Neoclassical canons. Laurens' own training was in the painting of historical subjects, and the principles he taught added yet another facet to the Meiji *yōga* movement.

Among the founding members of the Pacific Painting Society was Nakagawa Hachirō (1877–1922), who began his training under Koyama Shōtarō at the Fudōsha. After three years there, he left for the United States and Europe, and on his return in 1901 helped establish the Pacific Painting Society. He went abroad once more, and for the remainder of his career sub-

100. Ishii Hakutei: Relaxing on the Grass. *Oil. 1904. National Museum of Modern Art, Tokyo.*

mitted paintings to the Bunten. *End of September* (Plate 89) represents Nakagawa's simple, natural style and his sensitive understanding of the subtle changes of light that mark the passing of the seasons.

Mitsutani Kunishirō (1874–1936) was a leader of the Pacific Painting Society and later became affiliated with the Bunten group. Though his style altered noticeably after his two visits to the West, he was painting in a simple manner at this point, using scenes of daily life for subject matter (as in *Upstairs,* Plate 102) and applying the well-structured skills of Neoclassical realism learned from Laurens. He actively participated in the Pacific Painting Society exhibitions and in 1907, *Slight Illness* (Plate 92), showing a sick child tended by his mother, was submitted to the Tokyo Industrial

Exposition. With the opening of the Bunten, Mitsutani was elected to the judging committee of the *yōga* division along with Asai Chū, Koyama Shōtarō, and Nakamura Fusetsu.

Among the young Japanese painters, perhaps the one who most clearly conveyed the style of Laurens was Kanokogi Takeshirō (1874–1941). *European Lady* (Plate 94) was one of his works painted abroad and returned to be exhibited in the third Pacific Painting Society exhibition. Here the prominent elements of his style are his strength in rendering the form of his subject and his skill at using light and shadow to create a feeling of depth and volume. Kanokogi made a return visit to France and to his mentor in 1906, during which time he completed the *Portrait of Master*

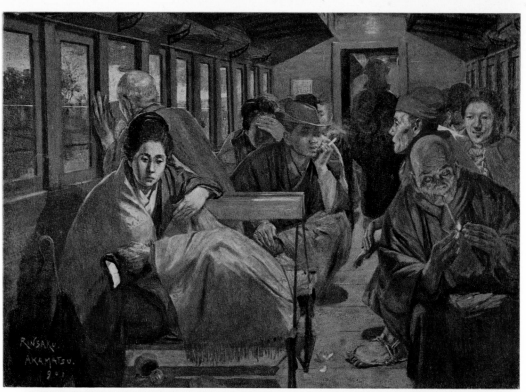

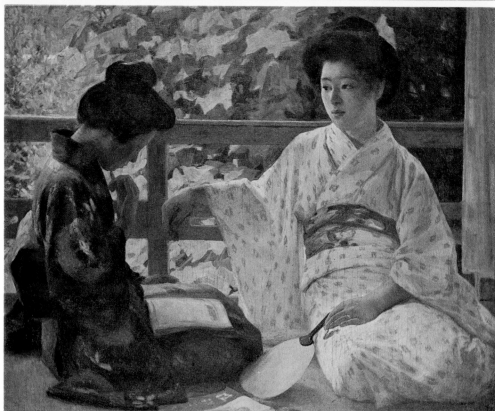

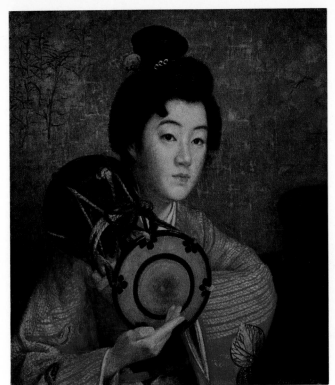

103. *Okada Saburōsuke:* Portrait of a Lady. Oil; *ht 76, w 60.5 cm. Okada never stepped out of the framework of plein-air techniques that he learned first as a student of Kuroda Seiki and then of Raphael Collin in France, but he absorbed and combined it with his own sense of Japanese aesthetics. This portrait of a lady from the seventeenth-century Genroku era is representative of his work and is characteristic of the quiet elegance for which he is known. 1907. Bridgestone Museum of Art, Tokyo.*

◁ 101. *(above) Akamatsu Rinsaku:* Night Train. Oil; *ht 160, w 199 cm. In this scene of a third-class car in a night train, the painter is absorbed in studying the effects of various light sources on the passengers: a dim electric ceiling light, the glare of a match, and the white glow of the dawning sky combine in the atmosphere of the smoke-filled car. This work, which was shown at a White Horse Society exhibition, reflects a social consciousness often seen in plein-air works. 1901. Tokyo University of Arts.*

◁ 102. *Mitsutani Kunishirō:* Upstairs. Oil; *ht 105.5, w 120.6 cm. Two young girls relax on a second-floor balcony against a background of paulownia trees. The scene is uncomplicated in composition and mood, and there is a coolness as though a breeze were moving within the different planes of the painting. Mitsutani was an active member of the Pacific Painting Society, which formed in competition to the White Horse Society, and his work reflects the understanding of painting in natural light gained in the late Meiji era. 1910. Tokyo National Museum.*

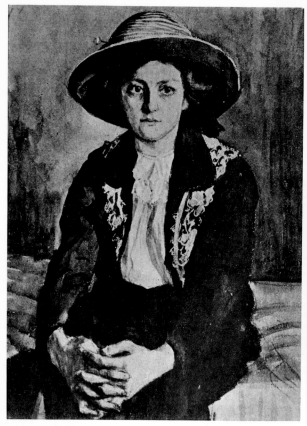

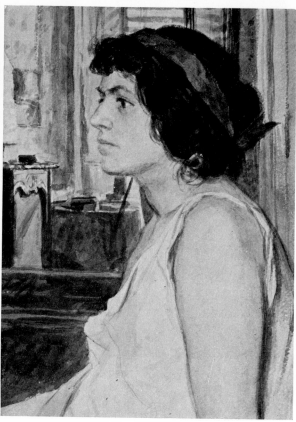

104. Ishii Hakutei: German Woman. *Watercolor. 1912. To-kyo National Museum.*

105. Ishii Hakutei: Hotel in Paris. *Watercolor. 1911. Tokyo National Museum.*

Laurens (Plate 93). Kanokogi's permanent residence was in Kyoto, where he followed Asai Chū as president of the Kansai Academy of Art. He also worked as an instructor at the Kyoto Higher Industrial Art School, and was for many years a strong influence on Japanese Western art circles in the Kansai area.

At the third Pacific Painting Society Exhibition, Ishii Hakutei (1882–1958) presented *Relaxing on the Grass* (Plate 100), a painting in which the soft dabs of the brush and the brilliant contrast of clear colors identify it as an Impressionistic work in the style taught by Kuroda Seiki and Fujishima Takeji at the Tokyo Art School. Ishii was the son of a *nihonga* painter who early displayed a talent for art. He began instruction in Western-style principles under Asai Chū

after his father's death, and then studied at the Tokyo Art School. Upon his return from a trip through Europe in 1910, he joined with the group of young dissidents to form the Nika-kai. Ishii, primarily an artist, is also known for his poetry and critical essays.

Nakamura Fusetsu (1866–1943) began his career as a *nanga* painter but turned to Western-style art in 1888, when he entered the studio of the Society of Eleven to work under Asai Chū and Koyama Shōtarō. During his stay in France, which began in 1901, he worked first in the studio of Raphael Collin and later under Laurens. His *Founding of a Country,* exhibited in 1903 at the Tokyo Industrial Exhibition, is a good example of his style. Nakamura also became known for the controversy some of his canvases of semi-nude

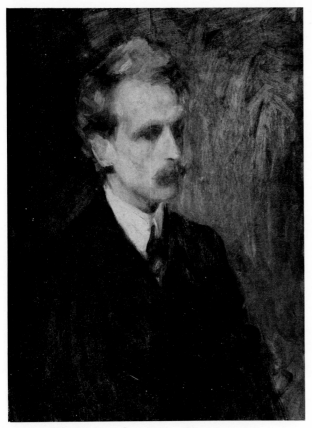

106. Hara Bushō: Portrait of the Artist Henry. *1907. Oil.*
Private collection.

women aroused, but he spent his later years as a mem-
ber of the establishment, educating the next genera-
tion of painters as president of the Pacific Art School
and studying calligraphy.

Two artists who were not directly affiliated with
any particular group, but are representative *yōga* paint-
ers, are Hara Bushō (1866–1912) and Kojima Torajirō
(1881–1929). Hara began his training at the Kyoto
Metropolitan Art School and continued his studies in
London, where he studied for three years. The illness
that overtook him soon after his return prevented
him from producing much in the closing years of his
life. *Portrait of the Artist Henry* (Plate 106) and *Violinist*
are his only two extant works, but his gifts as an artist
are expressed in his eye for suggesting an inner depth

in his canvases through subtle contrasts of light and
dark.

Kojima studied at the Tokyo Art School and was
Aoki Shigeru's classmate. He also spent some years in
Europe, and worked under Raphael Collin as well as
under Emile Klaus at the Ghent School of Art. During
his stay in Belgium, he painted *Begonia Garden* (Plate
108), in which he built up forms from nimble dashes
of bright colors. Kojima was probably one of the
first Meiji painters to understand and put into practice
the principles of the Impressionist school. He is also
known for the collection of works he assembled in
Europe for the Ohara Art Museum in Kurashiki.

By the end of the century and only fifty short years
in the making of a stylistic tradition, the artists work-

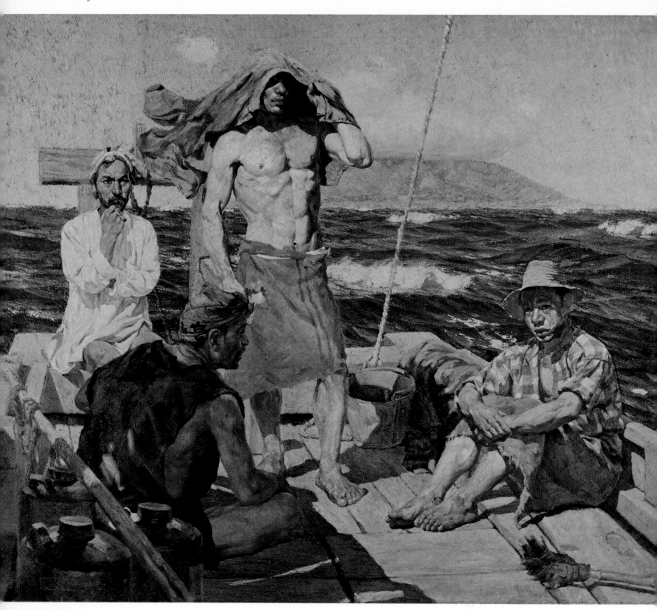

107. *Wada Sanzō:* South Wind. *Oil; ht 149, w 187 cm. While yet unknown in art circles, Wada was awarded second prize for this painting at the first Bunten exhibition in 1907. There is an uncanny vibration to the painting most noticeable in the brilliant luminosity of the figures painted in direct sunlight. The muscular central figure provides the main axis for the painting, set off by the diagonal rope to the right and by the seated figure in white to the left. A tension of line and gaze pulls the four figures into a tightly organized composition, against the background of Izu Oshima island and an expansive sense of the sea. At the time of the Bunten, the work was acclaimed for its combination of strength and luminosity. 1907. Tokyo National Museum.*

108. Kojima Torajirō: Begonia Garden. *Oil. 1910. Ohara Art Museum, Okayama Prefecture.*

ing in the *yōga* style had come to be a wildly assorted group indeed. But a closer look at the events of the end of the nineteenth century clearly shows that the rapid pace of experimentation and change in Western-style painting up to that moment was beginning to slacken. The White Horse Society, originally the catalyst for and the mainstream of the movement, had begun to lose its appeal; only Aoki and Fujishima were still producing fresh and stimulating canvases. Even the rivalry between the White Horse Society and the

Pacific Painting Society had lost all meaning as the fundamental differences between their styles and teachings became blurred. Once again the field of art was dominated by uninspiring subject matter rendered in time-worn techniques, and painting as a whole slipped into a period of mediocrity. In the face of this dilemma, the reorganization that gave rise to the Bunten, a series of exhibitions sponsored by the Ministry of Education beginning in 1907, served to give *yōga* a new stimulus.

6

The Bunten

The new Bunten organization was formed in response to an appeal made to Makino Nobuaki, Minister of Education, by three leading figures of the art world, Masaki Naohiko, director of Tokyo Art School, Otsuka Yasuji, a member of the faculty of Tokyo Imperial University, and Kuroda Seiki. These three had petitioned the Japanese government to create a forum for art patterned after the official French Salon. The organization of exhibitions, to be held under the auspices of the Ministry of Education, was under full discussion in June 1907; by August, the regulations governing the exhibits had been decided upon, and the initial exhibition was opened to the general public for one month from October to November 1907 at the Tokyo Industrial Art Museum in Ueno Park.

The Bunten was divided into three sections: Japanese-style painting, Western-style painting, and sculpture, each with a jury committee of its own. The thirteen members of the committee elected to judge the *yōga* division included one author, Mori Ogai, and several painters, Kuroda Seiki, Kume Keiichirō, Koyama Shōtarō, Asai Chū, Mitsutani Kunishirō, and Nakamura Fusetsu. A total of 91 works were selected for exhibit from among 327 submitted, including some by the jurors themselves. This being the first official effort to assemble together under one roof representative works of the numerous circles and schools of

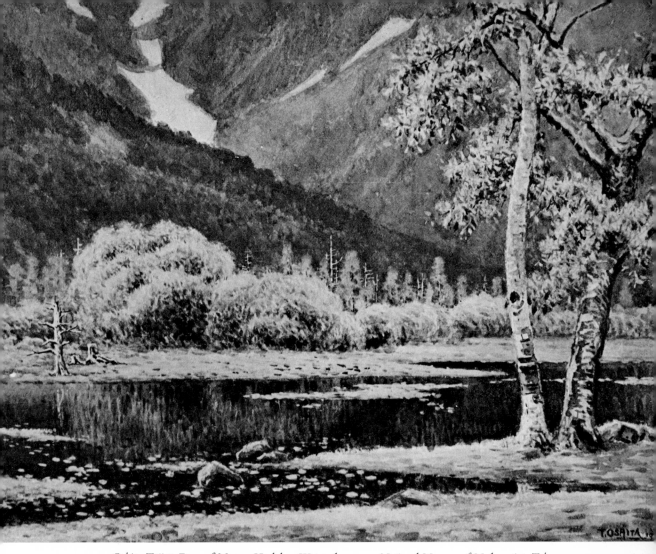

109. Oshita Tōjirō: Foot of Mount Hodaka. Watercolor, 1907. National Museum of Modern Art, Tokyo.

Western-style art, the Bunten received an enthusiastic response and attracted a wide audience. These exhibitions established a rather strong tradition over the years, under the name Bunten until 1918, after which they were renamed the Teiten. They continue today as the Nitten, and are held in Ueno every fall.

One objective of the *yōga* division of the Bunten was to coordinate the numerous contending art factions into one central organization. In so doing, a new climate was created in which the members of the White Horse Society and the Pacific Painting Society were able to coexist and to present their works to the public. For many unknown artists who were in search of new and more profound levels in art, the Bunten provided an excellent opportunity to launch themselves into a career. But the new mediocrity that had settled into official *yōga* circles judged their radical originality so harshly that they were finally rejected for being something akin to heretical. The kinds of paintings given prominence in the exhibits also reflected their conservatism. This narrow-mindedness was to account for a resentment on the part of the *yōga* painters that spread in the early 1910s and challenged the uncompromising official stand.

The Meiji Bunten

The style of Collin, Kuroda, and the White Horse

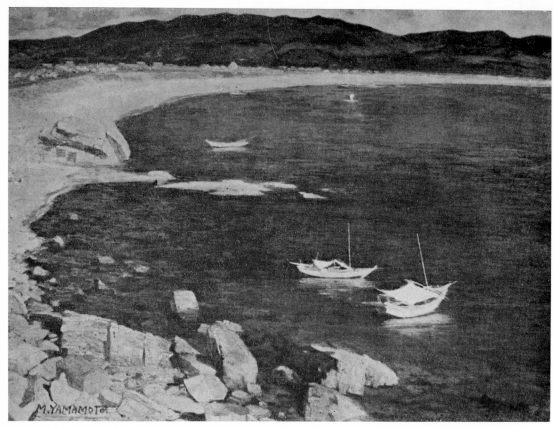

110. Yamamoto Morinosuke: Winding Inlet. *Oil. 1908. National Museum of Modern Art, Tokyo.*

111. Oshita Tōjirō: Oze Pond. *Watercolor. 1908. Private collection.*

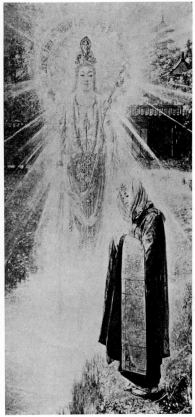

112. Mitsutani Kunishirō: The Rickshaw Man's Family. *Oil. 1908. Tokyo University of Arts.*

113. Nakazawa Hiromitsu: Reminiscences. *Oil. 1908. National Museum of Modern Art, Tokyo.*

Society had become the style of the painters affiliated with the Tokyo Art School. And in time, the academic style as represented by the influential Bunten, the only official exhibition, was linked to the White Horse Society style. Even the minor works exhibited at the Bunten reflected the sunlight of the Impressionist palette and in the Meiji years of the exhibitions, it dominated the *yōga* division.

A number of works still come to mind when recalling the early Bunten exhibitions. In the first Bunten, the second prize was awarded to a totally unknown artist by the name of Wada Sanzō for his work *South Wind* (Plate 107), an award which gave particular encouragement to younger artists. *South Wind* is a seascape with fishermen relaxing in a boat against a background of Izu Oshima and breaking whitecaps.

The composition is dramatic in the tense interplay among the figures and the glare of direct sunlight, and yet exudes youthful energy and confidence. Wada was awarded another second prize in the Bunten in 1908, and these two award-winning works established his reputation and won for him in 1909 a Ministry of Education scholarship to further his studies in Europe.

The watercolor medium had been advanced earlier under the influence of Charles Wirgman but had received little notice while the possibilities of oils were being explored. At the turn of the century, however, there was a buying market for watercolor paintings, many of which were being sold or shown in American museums and art clubs. Two outstanding watercolor paintings from the first Bunten are Yoshida Hiroshi's *New Moon* (Plate 118) and Oshita Tōjirō's *Foot of*

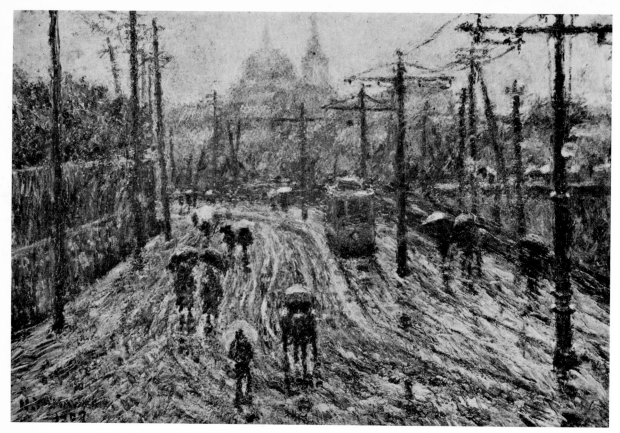

114. Yamawaki Shintoku: Rainy Evening. *Oil. 1908. Kōchi Central Public Hall.*

Mount Hodaka (Plate 109). In the former painting the artist's intuitive sense of poetic lyricism predominates, while Oshita's work is one in which the use of subdued color leaves a strong impression on the viewer. Oshita's *Oze Pond* (Plate 111) is painted with the same eye for spatial composition and subdued colors.

Yamamoto Morinosuke's *Winding Inlet* (Plate 110) received second prize in the second Bunten; it suggests the nostalgia for a rocky corner of Japanese coastline through subdued, barely visible brushstrokes. *The Rickshaw Man's Family* (Plate 112), submitted by Mitsutani Kunishirō, was another of the notable works to appear in that exhibition.

A work of mystical nature and Romantic mood, *Reminiscences* (Plate 113), by Nakazawa Hiromitsu, was awarded second place in the third Bunten held in 1909. The subject is a Buddhist nun pausing in her steps, deeply immersed in her thoughts of Shō Kannon, the Buddhist deity who personifies compassion and healing, who is manifested before her. Another work from that exhibition notable for the controversy it caused was *Station in the Morning,* submitted by an unknown artist, Yamawaki Shintoku. The canvas was lost during the World War II, but his radical Impressionist style brought forth both praise and outrage. His *Rainy Evening* (Plate 114) is painted in the same style of free-flowing, strong strokes, and foreshadowed the new trends soon to emerge in *yōga* painting.

At the fourth Bunten in 1910, Yamashita Shintarō and Nakamura Tsune displayed outstanding works. Yamashita's two paintings, *Woman with Shoes* (Plate 119) and *Reading* (Plate 115), were among the works

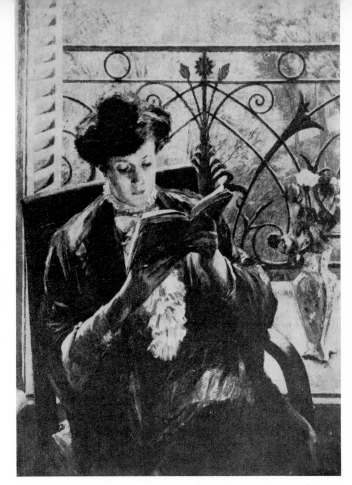

115. Yamashita Shintarō: Reading. *Oil. Bridgestone Museum of Art, Tokyo.*

he produced while abroad. His choice of warm, rich colors reflects that found in the style of Renoir, whose works he deeply admired. These two paintings, together with those Fujishima Takeji did in Europe, sent a fresh breeze of innovation through Japan's Western-style painting.

Seaside Village (Plate 122) launched Nakamura Tsune's well-deserved reputation as a painter. He was almost totally self-taught, and was plagued with both ill health and bad fortune from childhood. The scene of a fishing village bathed in brilliant sunlight leaves the viewer with a feeling of warmth and openheartedness as he senses that this was a moment of good health and vigorous spirits for the painter. The accent placed on pure color, used exclusively for modeling and shading, is especially fresh. The elements of style,

though separated by only a few years from the landscapes of Yoshida and Yamamoto, clearly announced the appearance of a new artistic sensitivity. Perhaps the most famous work by Nakamura is the *Portrait of Eroshenko* (Plate 116), a blind Russian poet whom he met in Tokyo. The style is clearly reminiscent of the warm, vibrant colors found in Renoir's painting.

Riverside Village (Plate 117) by Kosugi Misei drew a great deal of attention at the fifth Bunten. The composition, which is mural-like in its focus on a monumental central figure, shows an old fisherman holding a fishnet and standing in the bow of a small boat. The background remains flattened to the surface by turning up the small channel of water, the bank with ducks, and a standing row of poplars, and this flattened, decorative surface suggests an Oriental in-

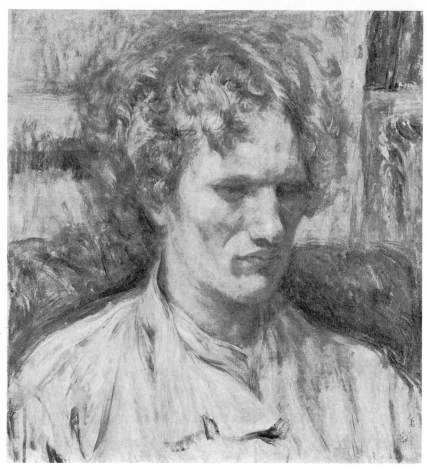

116. *Nakamura Tsune:* Portrait of Eroshenko. *Oil. 1920. National Museum of Modern Art, Tokyo.*

117. *(opposite) Kosugi Misei:* Riverside Village. *Oil. 1911. National Museum of Modern Art, Tokyo.*

fluence. Kosugi was director of the *yōga* department in the revived Japan Academy of Art, and in this painting revealed his personal inclination toward a Western-style art with Eastern overtones. Also exhibited in the fifth Bunten was Yamashita's *By the Window* (Plate 120), Sakamoto Hanjirō's *Coast,* and Nakamura Tsune's *Woman.* The sixth exhibition in 1912 included among its exhibitors Minami Kunzō and his work, *A Day in June* (Plate 121).

Meiji to Taishō: Apprenticeship to Independence

Toward the closing years of the Meiji era, the Bunten began to evince signs of hardening into conventionality. Finding themselves comfortably protected by the prestige and authority of the official institution, the Bunten judges selected paintings of a repetitive, *déjà-vu* sort. The same ideas came to be repeated from one exhibition to another, and anything new presenting a challenge to that authority was clearly opposed.

After coming away from the sixth Bunten, Natsume Sōseki, the contemporary novelist, disturbed by what he had seen, aptly described the pervading atmosphere: "The biggest problem in art is that of being accepted or rejected by the judges of the Bunten, for only the works they sanction are set before the public. In addition, only those painters who paint for the judges' approval will be able to make their way in the world as professional painters. As long as artists are forced to conform in this and produce mediocre, soulless

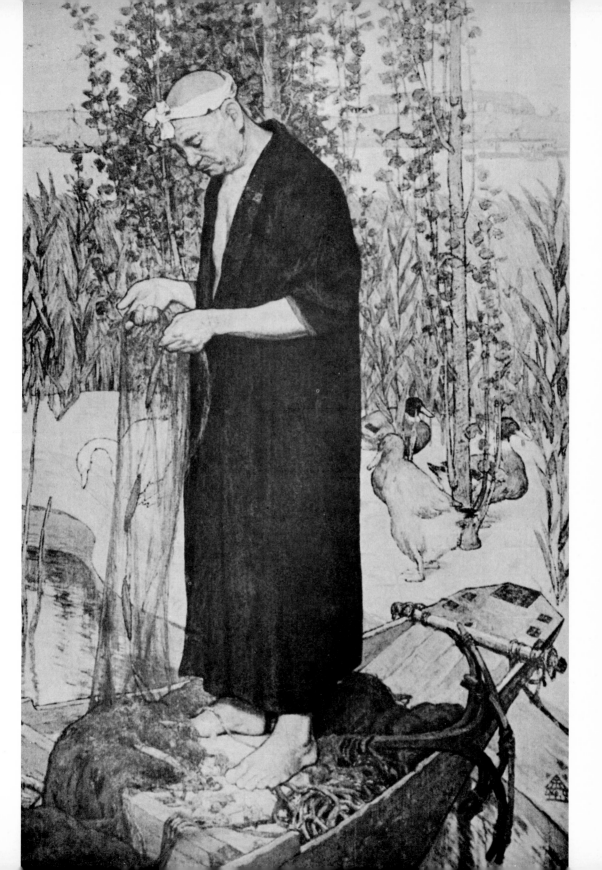

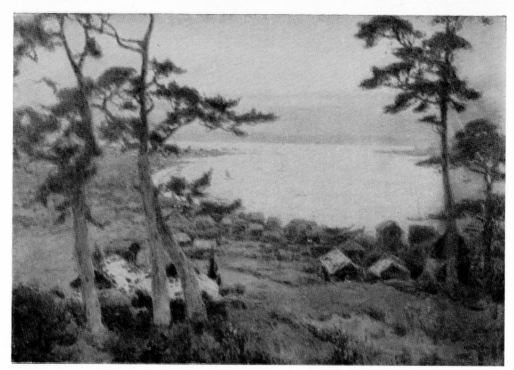

118. *Yoshida Hiroshi:* New Moon. *Watercolor; ht 59, w 79 cm. The scene is a hillside view of an inlet whose shore is dotted with houses faintly visible in the fading light of the evening sky. Everything appears to be submerged in the hazy air that is accentuated by the liquid texture of the watercolor medium. The painting won third prize at the first Bunten exhibition and represents a renewed interest in Western-style watercolor painting which had waned in popularity since it had been promoted by Charles Wirgman in the early days of the Meiji era. 1907. National Museum of Modern Art, Tokyo.*

119. *Yamashita Shintarō:* Woman with Shoes. Oil; *ht 72, w 60 cm. Yamashita studied in France under ▷ Raphael Collin and Cormon, and also saw the work of Velázquez and Renoir. He admired the latter in particular and absorbed much of Renoir's style into his own. Completed abroad, this work combines soft brushwork with warm shades of color, and along with his* Reading (Plate 115) *and* By the Window (Plate 120), *was respected as transmitting the new style inspired by the Impressionist school. 1908. Private collection.*

120. *Yamashita Shintarō:* By the Window. *Oil. 1911.*
National Museum of Modern Art, Tokyo.

works designed only to cater to the jurors' taste and popular approval, the consequences for art will be deplorable."

In 1912 several painters of the younger Bunten group petitioned Kuroda for a separate section of the Bunten in which to exhibit paintings of the new Western art styles, since the *nihonga* division had been granted such a section. Kuroda refused on the grounds that there were "no new schools in *yōga,* for it was all representative of the new style." Discouraged by the encounter, these younger painters joined in opposition to the official stand and in 1914 began their own group, called the Nika-kai (Second Division Group). The Nika-kai attracted several promising names through its declaration that "this exhibit is open to all who wish to participate, with the exception of those who have applied to the Bunten." Ishii Hakutei, Tsuda Seifū, Umehara Ryūzaburō, Yamashita Shintarō, Kosugi Misei, Arishima Ikuma, Sakamoto Hanjirō, Minami Kunzō, and Yasui Sōtarō helped to stir interest in the Nika-kai by competing among themselves for newer, more original modes of expression, and this sudden surge of creative experimentation was one event which set the tone of Western-style painting in the Taishō era. The three figures of most enduring reputation among these were Sakamoto Hanjirō, Umehara Ryūzaburō, and Yasui Sōtarō.

Sakamoto Hanjirō (1882–1969) and Umehara Ryūzaburō were exceptions in this mood of experimentation, for they resolved their personal styles at an early stage and worked within those styles for the duration of their careers. *Drying* (Plate 123) illustrates Saka-

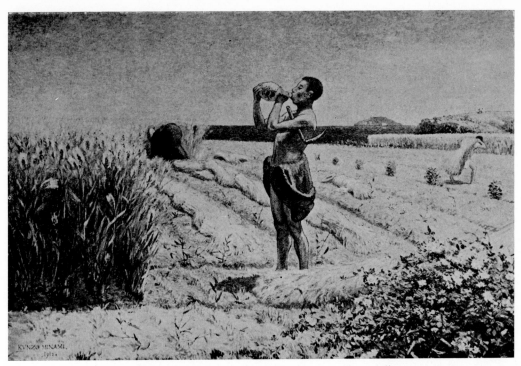

121. Minami Kunzō: A Day in June. *Oil. 1912. Private collection.*

moto's rich taste in color based on the Impressionist concept that rays of light rather than line create form and volume. Sakamoto's works consistently maintain a vision of nature similar to those of Monet and Pissarro, though he was always consciously striving to express this in a personal way. From the time of his entrance into the Nika-kai, he was establishing his own vision of color as reflected light.

Umehara Ryūzaburō (born 1888) was one of the most consistent painters stylistically to emerge from the Meiji-Taishō eras. He found his personal expression at a relatively early age, based on the warm colors of Renoir and the strong shapes of Rouault. Being from Kyoto, and growing up among the designers along Shijō Street, he was well acquainted with the decorative arts. He trained in Asai Chū's Kyoto atelier, and was an important contributor to the Nika-kai. What he sought to achieve in his art was freshness of nature through originality, not simply through style imitative of Western painting. His sense of beauty was marked by the colors and subject matter of Renoir, with whom he studied in France when Renoir was in his late seventies.

It is particularly in his portraits of women that his debt to Renoir is noticeable. *Necklace* (Plate 126) is such an example. It is a bright canvas of a young girl painted in Renoiresque colors against an orange background. The portrait of the young man in *Narcissus* (Plate 127) most directly expresses an uninhibited sensuousness in the use of warm pastel hues and unleashed brushwork.

Yasui Sōtarō (1888–1955) was a leading member

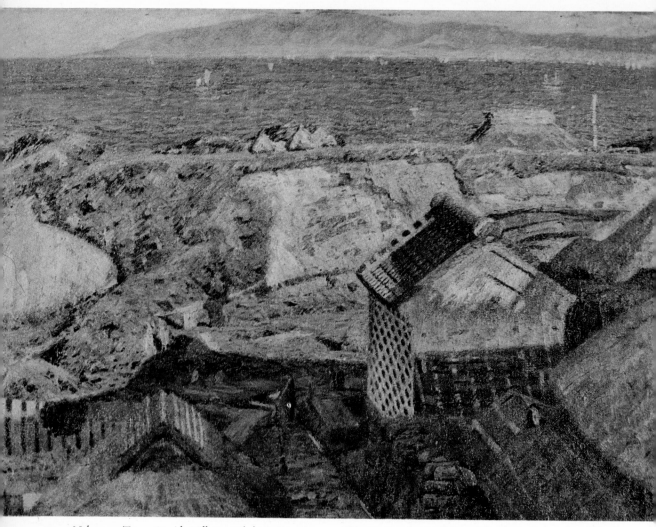

122. *Nakamura Tsune: Seaside Village. Oil; ht 60.8, w 82.1 cm. This painting shows a fishing village bathed in vivid sunlight, but the work is more than simple description, for it projects the emotions of the artist as well. Self-taught, Nakamura was strongly influenced by the palette and style of Renoir. It was the first of Nakamura's works to be exhibited and marked the rise of a new generation of artists in search of a purely subjective mode of expression. 1910. Tokyo National Museum.*

123. *Sakamoto Hanjirō: Drying. Oil; ht 117, w 71.3 cm. This painting represents Sakamoto's early resolution of the problem of* ▷ *light using soft, clear colors to give substance and shading to forms, as well as his debt to the color and style of Renoir. The reflection of light from the cloth onto the woman's arms, sleeves, and face unifies the various details of the painting and brings a subtle emotional quality to the scene. The model is the artist's wife soon after their marriage, and the painting was shown at the fourth Bunten exhibit. 1910. Private collection.*

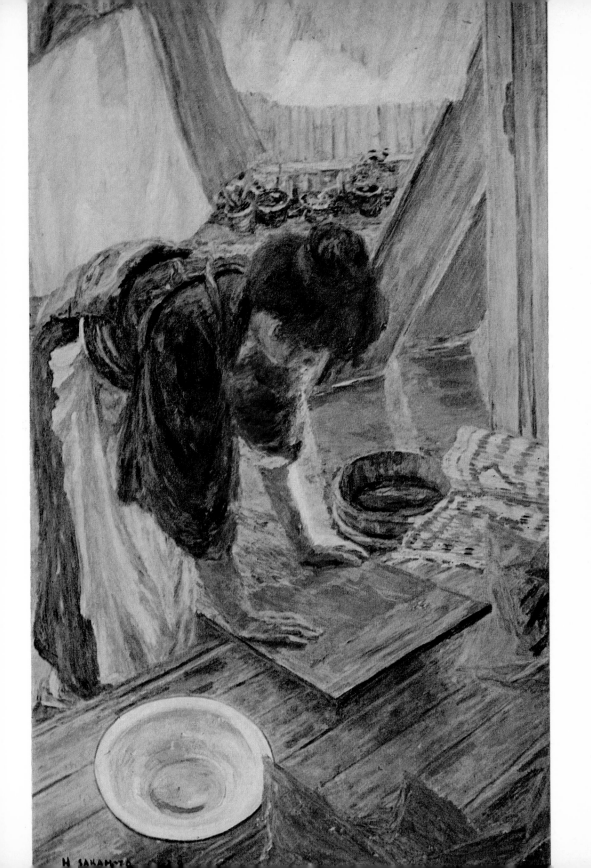

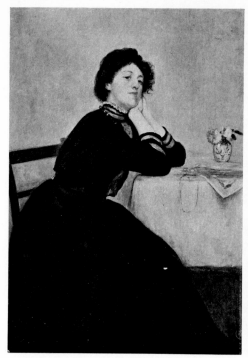

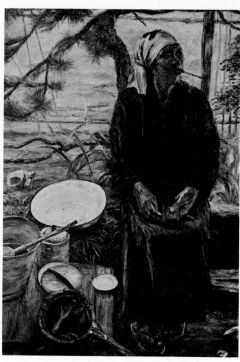

124. *Minami Kunzō:* Portrait of a European Lady. *Oil. 1901. Private collection.*

125. *Sakamoto Hanjirō:* A Woman Diver and Her Catch. *Oil. 1914. Bridgestone Museum of Art, Tokyo.*

of the Nika-kai who began his studies with Asai Chū. He traveled to Europe, where over an eight-year period (1912–20) he produced landscapes in the styles of Matisse and Pissarro. While in Europe he studied the classical style of the Académie Julian, later switching to the styles of Courbet, Sisley, Pissarro, and Cézanne. *Peacock and Woman* (Plate 129) and *Woman Washing Her Feet* (Plate 128) are particularly characteristic of the overwhelming volume of Yasui's nude forms. This as well as his sense of composition were studied by younger painters. After returning home from Europe, he became ill and produced little for several years, but emerged in the sixth Nika-kai exhibition with four paintings, landscapes and portraits painted with a new brightness and an eye for decorative surface detail that has since come to be known as the Yasui style.

The literary magazine *Shirakaba* (White Birch), established in 1910, included articles on contemporary art in each issue. It was the first vehicle through which major European artists such as Cézanne, Van Gogh, Gauguin, Matisse, and others were introduced to the Japanese public. One other source of expansive thinking was an essay by the poet and sculptor Takamura Kōtarō. On the eve of his return to Japan in 1908, his essay entitled "The Green Sun" appeared in another avant-garde magazine, *Subaru* (Pleiades). In it he spoke out for absolute freedom in art and the yet untapped, unlimited possibilities of artistic expression innate in the artist. "If I see something as blue, that someone else thinks is red, I would not argue with him, but rather deal with the redness itself. Should two or three people paint a green sun, I would not disagree, for it is possible that the sun may also appear

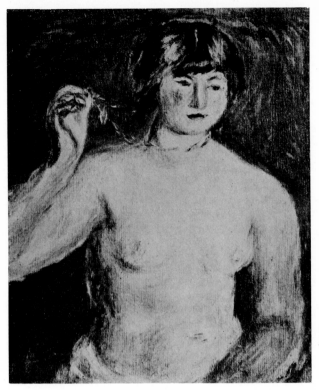

126. Umehara Ryūzaburō: Necklace. Oil. 1913. National Museum of Modern Art, Tokyo.

green to me." His proclamation, sometimes referred to as the Japanese Impressionist Manifesto, touched a deep strain within young Japanese artists once again reaching out for self-discovery and individual expression. Momentum was further accelerated by several young artists returning from Europe full of the animated air of Post-Impressionist Europe, with its manifold schools. With them another new era of Western-style art in Japan was soon to open in *yōga* circles.

Saitō Yori and Takamura Kōtarō were major contributors to art and literary magazines transmitting the main currents of Western art into Japan almost simultaneously with their development in Paris. News of the Impressionists, Post-Impressionists, cubism, Fauvism, and the styles of individual artists with their contrasting ideas of the meaning of light in structuring form was quickly absorbed by artists already stimu-

lated by the *plein-air* movement but thoroughly dissatisfied with the descriptive painting being chosen for exhibition in the Bunten. These young artists were intent on finding not only ultimate individual expression, but also a definition for individual truth.

It was in this context of intellectual ferment in the 1910s that Saitō Yori decided to hold a one-man show which resulted rather spontaneously in the informal organizing of the Fusain-kai, a group of particular importance since it began the independents' movement in Japan—that is, independence from the official Bunten style. In an essay entitled "The Independents," Saitō stated that Japanese oil painting had emerged from spontaneous expression and was being exhibited in a forum similar to the French Salon. Nonetheless, the net effect of these official exhibitions was that painters were being strongly influenced by the

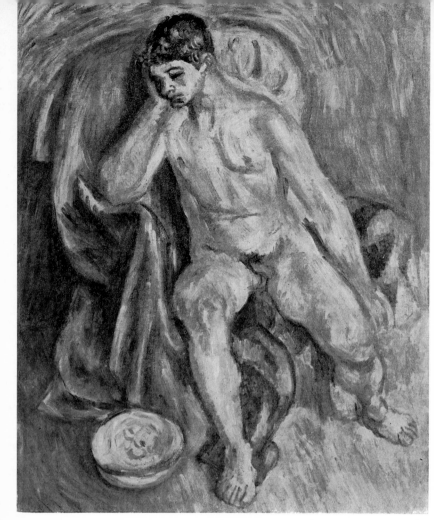

127. *Umehara Ryūzaburō:* Narcissus. *Oil. 1913. National Museum of Modern Art, Tokyo.*

128. *(opposite) Yasui Sōtarō:* Woman Washing Her Feet. *Oil. 1913. Private collection.*

academic style at the expense of creative freedom, and the answer to this was to be found in an independents' movement.

The history of the Fusain-kai has been difficult to document, as many of the works of the period have since been lost in fires during earthquakes and the air raids of World War II. Major research has been attempted by Oka Isaburō through interviews with the major participants in the group, and he has found that the circumstances of its forming and dissolution are indicative of the fluid state of Taishō art groups and of the rate at which the introduction of new ideas from Europe outdated the existing groups.

Saitō had originally intended to hold an independent show, but since nothing like a gallery existed to accommodate a limited exhibition, he gathered together enough artists of similar styles to fill a large room with paintings. A number of painters joined him, most of whom had been participants in the Bunten but had been uniformly disenchanted with the official circles and ready to form their own circle. Some of them were not affiliated with any particular group, but many came from small avant-garde groups experimenting with Fauvism and ideas from Cézanne and post-impressionism. By consenting to join with Saitō in his Fusain-kai, these groups lost their raison d'etre and dissolved, though their leaders emerged as central figures of the Fusain-kai.

Two of the leading members of the Fusain-kai were Kishida Ryūsei and Yorozu Tetsugorō. Kishida (1891–1929) was an eclectic painter who began exhibiting with the Bunten at the age of nineteen. Always in

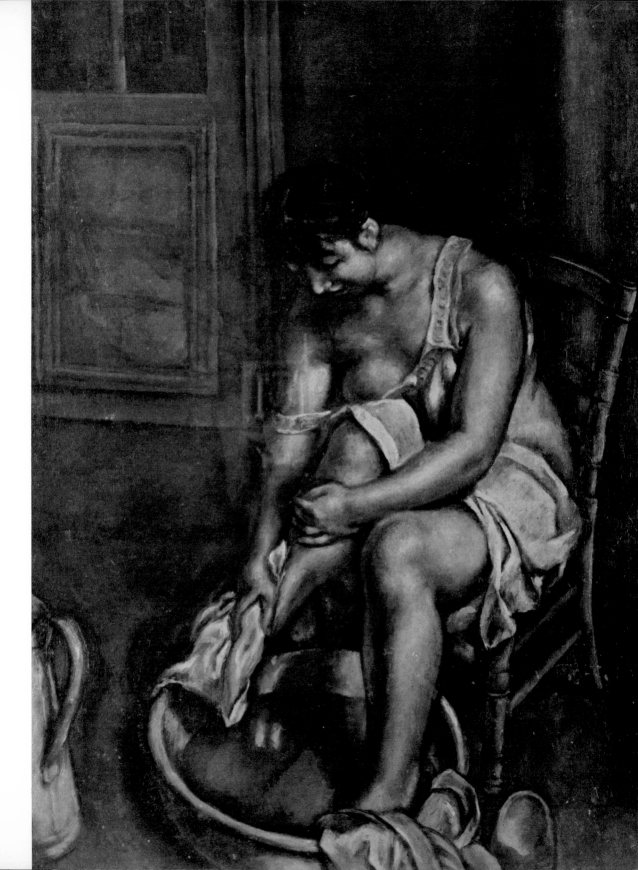

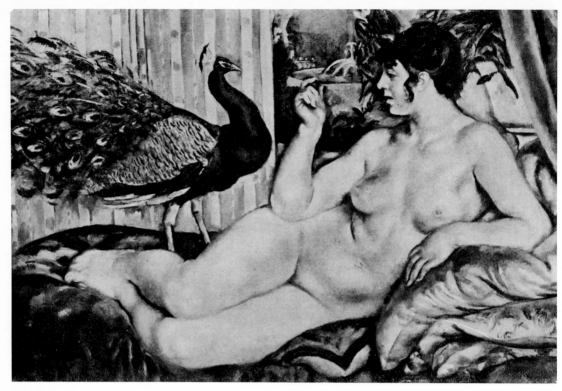

129. *Yasui Sōtarō:* Peacock and Woman. *Oil. 1914. Private collection.*

search of stylistic identity, he passed through many stages, beginning with *plein-air* principles, the Impressionists, and the Post-Impressionists. He also experimented with the style of the Fauves, after which he turned to northern European painters such as Dürer and Jan Van Eyck. Curiously, it was the *Shirakaba* magazine which first awakened him to the styles of contemporary art and it was also through this magazine that he learned the beauty of the classical schools. His final effort was an attempt to fuse elements of the classic beauty of the Renaissance with the modern period of Japanese-style painting, and his portraits of his daughter Reiko (Plate 130) represent this attempt.

The portraits of Reiko were painted in a series when she was a young child, and form a large part of his work. They are all arranged in a kind of human still life, but there is an intensity about them in the uniform seriousness and diverted stare of the child's eye. His style has had long-lasting appeal to the Japanese in its mixture of photographic likeness and decorative surface. Like so many others, Kishida ended his career in painting by turning to the traditional Japanese style, and these paintings breathe with an unmistakable freshness by contrast to his still-life style in oils.

Yorozu (1885–1927) was fundamentally an experimentalist and intellectual who went through many different styles. He was one of the earliest to study the thought and structural problems of cubism, though his early canvases in the style show a stiffness in technique. Several of his earlier works resemble the African masks and women that Picasso painted between 1907 and 1909, and the use of light and shading re-

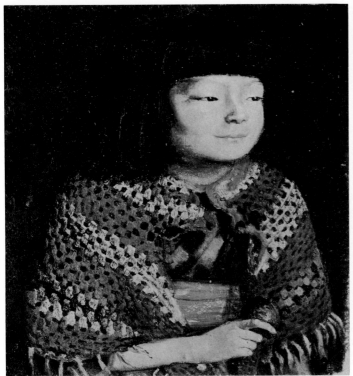

130. Kishida Ryūsei: Reiko Smiling. Oil. *1921. Tokyo National Museum.*

131. Yorozu Tetsugorō: Woman Leaning on a Wall. Oil. *1917. National Museum of Modern Art, Tokyo.*

sembles more the carved forms of sculpture than the fluid light and chromatic harmony of the Impressionists. Yorozu's figures imply monumentality in size and a simplification of background. The *Woman Leaning on a Wall* (Motarete Tatsu Hito, Plate 131) is one of the major works of Japanese cubism. The form of the woman has been reduced to a series of patterns and then rearranged in interlocking planes that seem to cohere both organically and compositionally. Guillaume Apollinaire wrote of the Cubists: "The secret aim of the young painters of the extremist schools is to produce pure painting. Theirs is an entirely new plastic art. It is still in its beginnings, and is not yet as abstract as it would like to be. Most of the new painters depend a good deal on mathematics without knowing it; but they have not yet abandoned

nature which they still question patiently, hoping to learn the right answers to the questions raised by life." At the end of his search into the Paris movements, Yorozu retired to Yokohama in 1919, where he took up traditional *nanga* painting.

All the members of the Fusain-kai were young, Takamura being the oldest at thirty. Saitō was the the founding figure around whom the members were organized, and only a month went into preparing the first exhibit. It was held simultaneously with the Bunten exhibition, which seemed to be a deliberate step to show their rebellious, anti-Establishment leanings. Thirty-three artists exhibited a total of 168 works, of which few are extant; the overall style was probably similar to that of the Post-Impressionists and the Fauves. News of the showing spread, drawing nota-

bles from all fields; Kuroda Seiki made an appearance along with figures from literary and theatrical circles.

The public reaction was generally one of bewilderment at an increasing expressionistic and subjective art for which they were totally unprepared and without any criteria to judge (which was exactly the dilemma facing the European public at about the same time). One critic wrote, ". . . it is impossible for me to discriminate between the works of first-rate and second-rate artists, for personal idiosyncrasies make this type of art harder to judge than the representational works of Kuroda and Okada being exhibited now at the Bunten. The *plein-air* painters conveniently form a unified school by contrast to this hodgepodge painted for art's sake." The unrestricted use of subjective color overwhelmed the senses of the observers, leaving many to conclude that the painters would generally have profited more by reevaluating the objects of nature as a whole rather than exploring the nature of subjective expression. "Apples wrought with corners, nude women who resemble clay figures, faces with juxtaposed features" all seemed to be difficult to accept as art.

The Fusain-kai followed up the first exhibition with another only four months later, though almost half the group had by that time resigned. Saitō, Yorozu, Kishida, and Takamura were among the continuing members. The greater feeling of homogeneity that characterized the group at the second exhibition was self-defeating. These artists, who had come together in a mutual search for the fullest possible understanding of nature in art and the meaning of truth, rebelled against the idea of being labeled anti-Establishment, or of being connected with any particular group or style. The demise of the Fusain-kai was further foreshadowed by the appearance of private salons and social gatherings held for the purpose of bringing artists together to discuss the problems of art and also to provide financial support for struggling painters. The Fusain-kai, which was organized and dissolved in a short six months (1912–13), provides a convenient termination point in this study of Meiji Western-style art, for it ushered in a new era of individualism and fearless exploration into new styles—a trend that would continue on into the 1930s.

Taishō *yōga* completely dissociated itself from the atrophied Meiji-era *yōga,* yet in their pursuit of total independence, the younger generation of painters overlooked the accomplishments of the previous period. They deprived themselves of the sense of continuity and equilibrium needed to cope with the stream of art theories and styles being introduced from Europe. The art of the Taishō era boasted tremendous variety but lacked depth, for the waves of modernism that inundated Japan left no time for any one style to be adequately absorbed. Meiji art was thus shunned by the early Taishō painters and left thereafter to the scrutiny and scholarship of present-day art historians and critics, who must pass judgment on its place in the long tradition of Japanese art.

In the short half century or so covered in this study of the Meiji era, the *yōga* movement expanded from a purely utilitarian concept of the value of Western art principles to the discovery of an aesthetic beauty in the oil medium, and finally to the point where Japanese sensitivity could be expressed through oil pigments on canvas surfaces. Among the artists who contributed to this direction, Kuroda Seiki stands out as the major figure in the transition from apprenticeship to fulfillment through his introduction of expressive light and painting from actual natural forms. By the end of this half century, an official academy had been formed under his influence with a style easily identifiable as a Meiji style. From there it was left to the Taishō painters to explore individual expression in the oil medium and to lead Western-style art circles in the direction of the European avant-garde and finally into the international style of the postwar period.

Glossary

Aoki Shigeru (1882–1911): most representative painter of the Romantic phase of Meiji painting; studied *plein-air* techniques under Kuroda at the Tokyo Art School, but leaned toward Romantic themes and a style of sensuous colors and vague figure drawing, often choosing Japanese legends and medieval history as subject matter

Asai Chū (1856–1907): the first *yōga* painter to translate the Japanese sensitivity to landscape into oils. He studied under Fontanesi at the Technical Art School, but took up the luminous palette of the Impressionists after a sojourn in France. Asai had been an instructor at the Tokyo Art School until he went abroad; after his return, he settled in Kyoto and opened a studio there.

Bansho Shirabesho: atelier established in 1856 by the government to study documents relating to the West. Its name was changed to the Kaisei-jo in 1863, but the program of study was not altered— the Dutch language, sciences, military skills, architecture, engineering, cartography, and Western art as a descriptive tool.

Barbizon school: a group of mid-nineteenth-century French painters led by Theodore Rousseau and also known as the Fontainebleau school, noted for landscapes done in muted colors and their exploration of the effects of natural light on nature; often considered the forerunners of the Impressionists

Bunten: the annual exhibitions sponsored by the Japanese Ministry of Education beginning in 1907 and organized like the French Salon; composed of three sections, Western-style painting, Japanese-style painting, and sculpture, the exhibitions have continued to the present, now under the name Nitten, and are held annually in Ueno

Chōkō Dokuga-kan: the atelier of Kawakami Tōgai (1827–81) founded in Tokyo in 1869 as one of the early private institutions teaching oil painting techniques

Fauvism: term used to describe the ebullient colors and structural distortions in the work of certain artists, especially Henri Rousseau, Matisse, Derain, Vlaminck, and Rouault, as they appeared in the 1905 exhibition of the Salon d'Automne; influenced Japanese artists through the exhibits of the Fusain-kai in 1912–13

Fenollosa, Ernest F. (1853–1908): a young Harvard graduate who in 1878 came to Japan to lecture on philosophy, political science, and economics, but soon became an outspoken advocate of the traditional arts and an active participant in the movement to save them. He helped establish a classification system for national treasures, prevent the wholesale buying of ancient art by foreign collectors, and revive the style of the Kanō school.

Fontanesi, Antonio (1818–81): a member of the Barbizon school of landscape painters from the Turin Royal Academy of Art; invited to teach at the Technical Art School, his style had a lasting influence on the early period of *yōga* in Japan

Fusain-kai: a short-lived, loosely organized group of avant-garde artists whose style was based on that of the Fauves and the Post-Impressionists and whose exhibitions set the pace and direction of an art movement during the Taishō era

impressionism: the most influential late nineteenth-century French art movement, whose followers studied the variations in natural light and created forms on canvas through touches of pure color rather than through the classical reliance on contrasts of light and dark to delineate by shading

Kanō school: the official painting school of the Tokugawa government during the Edo period (1603–1868) whose style had originated in the Chinese monochrome ink paintings introduced into Japan during the thirteenth and fourteenth centuries

Kuroda Seiki (1866–1924): the major figure in Meiji Western-style painting, whose introduction of the principles of his concept of *plein-air* realism changed the course of Western-style art in Japan. Kuroda taught at the Tokyo Art School and was a founder of the White Horse Society, whose style dominated art circles during the Meiji era.

Meiji Art Society (Meiji Bijutsu-kai): the earliest Western-style painting organization in Japan, whose leaders were Asai Chū and other graduates of the Technical Art School who painted in the style of Fontanesi

nanga: style of monochrome ink painting popular from the eighteenth century on, based on traditional art concepts and painted by amateur scholar-artists in personal, often idiosyncratic styles

nihonga: Japanese-style painting in the modern period, characterized by the use of traditional materials and methods

Nika-kai: group of dissident Bunten members who formed their own society in 1914 at the time of the seventh Bunten exhibit

Pacific Painting Society (Taiheiyō Gakai): group formed in 1901 by artists who had learned Neoclassical principles under Laurens in Europe and were eager to break with the dominant *plein-air* school

plein-air: term first used to describe the work of the Barbizon school of painters in studying the effects of natural light on landscape, but in Japan synonymous with the movement led by Kuroda Seiki and Kume Keiichirō and the work of the White Horse Society

Post-Impressionists: name given to a group of artists, including Seurat, Cézanne, Van Gogh, and Gauguin, for whom impressionism was a point of departure in searching for a new manner of constructing natural forms. Their work was introduced into Japan through the *White Birch* magazine and the artists returning from Europe in the early years of the twentieth century.

Shijō school: school of painting that combined traditional art techniques and concepts with certain elements of Western art principles to create a new style

Society of Eleven (Jūichi-kai): group of eleven Technical Art School students who resigned in 1878 to form their own organization in dissatisfaction with Fontanesi's replacement

Takahashi Yuichi (1828–94): early pioneer in *yōga* whose painting *Salmon* marked a turning point in the establishment of the Western style as a new art form

Technical Art School (Kōbu Bijutsu Gakkō): school established in 1876 as part of the Technological College to begin a program of formal training in Western art techniques as part of the government's modernization drive. One of its most influential teachers was the Italian Fontanesi, who died the year before the school closed in 1882.

Teiten: name given to the Bunten exhibitions after 1918

Tenshin Dōjō: atelier of Kuroda Seiki and Kume Keiichirō opened in 1894, whose students were also members of the White Horse Society and exhibitors at the Bunten; center of the mainstream of *yōga* for a time

Tokyo Art School (Tokyo Bijutsu Gakkō): government-sponsored art school established in 1887. In its first decade, the school was dominated by exponents of traditional art such as Okakura Tenshin, and specifically excluded Western-style art from its curriculum. In 1896, a Western-style painting department was finally set up with leading figures such as Kuroda Seiki as lecturer. The school continues today as the Art Department of Tokyo University of Arts.

Tosa school: official school of art patronized by the imperial family throughout the Edo period (1603–1868) which based its themes and motifs on the traditional *yamato-e* style

White Horse Society (Hakuba-kai): group organized in 1896 by Kuroda Seiki based on *plein-air* principles, whose style came to be known as the *murasaki* (violet) school because of the contrast between its palette and that used by the Meiji Art Society, which was known as the *yani* (resin) school. It was the successor of the Meiji Art Society as the dominant school of Western-style art.

yamato-e: traditional Japanese-style painting, often done in color, and used for narrative scrolls, intimate landscape scenes, and illustrations of medieval classical literature and important historical events

yōga: term used for Western-style painting using material such as oils to differentiate it from *nihonga*

Bibliography

Bridgestone Gallery. Tokyo: Bridgestone Gallery, 1965.

Brooks, Van Wyck: *Fenollosa and His Circle.* New York: Dutton, 1962.

Chipp, Herschel B.: *Theories of Modern Art.* Berkeley, Calif.: University of California Press, 1970.

Chisolm, Lawrence W.: *Fenollosa, the Far East and American Culture.* New Haven, Conn.: Yale University Press, 1962.

Fifty Painters of Japan. Japan Fine Arts Dealers Association, 1966.

Horioka, Yasuko: *The Life of Kakuzō.* Tokyo: Hokuseidō Press, 1963.

Masterpieces of the Bunten Exhibitions. Kyoto City Art Museum, 1966.

Noma, Seiroku: *The Arts of Japan,* vol. 2, late medieval to modern. Glenn T. Webb (tr.). Tokyo: Kodansha International, 1967.

Novotny, Fritz: *Painting and Sculpture in Europe, 1780–1880.* Pelican, 1960.

Paintings of the Meiji Era. Kyoto City Art Museum, 1968.

Shively, Donald (ed.): *Tradition and Modernization in Japanese Culture.* Princeton, N.J.: Princeton University Press, 1971.

Uyeno, Naoteru (ed.): *Japanese Arts and Crafts in the Meiji Era.* Richard Lane (tr.). Centenary Culture Council Series, vol. 8. Tokyo: Pan-Pacific Press, 1958.

Collected Works

Gendai Nihon Bijutsu Zenshū, vols. 2, 4. Tokyo: Kadokawa Shoten, 1953.

Kindai Nihon Bijutsu Zenshū, vols. 3, 4. Tokyo: Tōto Bunka Kōekisha, 1953.

Kindai no Bijutsu, vols. 1–20. Tokyo: Shibundō, 1970–

Nihon Bijutsu Zenshū, vol. 2. Tokyo: Bijutsu Shuppan-sha, 1960.

Nihon Kindai Kaiga Zenshū, vols. 1–6, 10, 12. Tokyo: Kōdansha, 1962–63.

Index

The Arts of Japan Series

These books, which are a selection from the larger series on the arts of Japan published in Japanese by the Shibundō Publishing Company of Tokyo, will in future volumes deal with such topics as haniwa, ink painting, architecture, furniture, lacquer, ceramics, textiles, masks, Buddhist painting and sculpture, and early Western-style prints.

Published:

1 Design Motifs
2 Kyoto Ceramics
3 Tea Ceremony Utensils
4 The Arts of Shinto
5 Narrative Picture Scrolls
6 Meiji Western Painting

In preparation:

Ink Painting
Haniwa

The "weathermark" identifies this English-language edition as having been planned, designed, and produced at the Tokyo offices of John Weatherhill, Inc., in collaboration with Shibundō Publishing Company. Book design and typography by Dana Levy. Text composed by Kenkyūsha. Engraving by Hanshichi. Printing by Nissha and Hanshichi. Bound at Oguchi Binderies. The type of the main text is set in 11-pt. Bembo with hand-set Goudy Bold for display.